Calligraphy

MICHAEL GULLICK

STUDIO EDITIONS
LONDON

PUBLISHED BY STUDIO EDITIONS LTD
PRINCESS HOUSE, 50 EASTCASTLE STREET
LONDON W1N 7AP, ENGLAND

COPYRIGHT © STUDIO EDITIONS 1990

ISBN 1 85170 604 6

PRINTED IN HONG KONG

ACKNOWLEDGEMENTS

For permission to reproduce photographs the author and publishers are grateful to: the British Library, London, Plates 2 (Add 5412), 3 (Harley 1775), 4 and 5 (Cotton Nero D iv), 6 (Cotton Vesp A i), 9 (Harley 2788), 10 (Add 10546), 11 (Add 37517), 12 and 13 (Harley 2904), 17 (Add 49622), 18 (Add 42130), 21 (Add 15246), 22 (King's 24), 23 (Harley 4425), 24 (Royal 12 C viii), 25 and 26 (Add 31845), and 28 (Lansdowne 63); the Bodleian Library, Oxford, Plates 6 (Hatton 48), 8 (Douce 176), and 19 (Eng poet a I); the Staatsbibliothek, Berlin, Plate 20 (Lat fol 384); the Master and Fellows, Jesus College, Oxford, Plate 15 (Jesus 63); the Victoria and Albert Museum, London, Plates 27 (L-2090-1937), and 31 (L-1879-1964); the National Library of Wales, Plate 34; the Klingspor Museum, Offenbach, Plate 32; Paul Klee Foundation, the Museum of Fine Arts, Berne, Plate 33; and the Red Gull Press, Plate 14. Plates 1, 16, 29, 30, 35, 36, 37, 38, 39 and 40 are reproduced from photographs in the author's possession or photographs supplied to the author by owners or artists.

INTRODUCTION

Only a little more than five hundred years ago all books were written by hand. The earliest printed books appeared in the 1450s and it was then possible to produce multiple copies of a text rapidly. Medieval scribes and early printers would be astonished to learn that today there are machines which can not only read but also write. Recent innovations in communications technologies have brought about enormous changes in the way we think, but at the same time there is more interest than ever before in traditional crafts and skills, including the craft of writing, or calligraphy. Calligraphy means beautiful writing and the word was coined only in the seventeenth century. Earlier, when writing was strictly a useful craft, the notion of associating it with beauty would probably have been regarded with some suspicion, although there is no doubt that fine writing and good scribes were highly esteemed. Then, as now, the act of writing was a very personal one; it involves movement and touch, a peculiarly direct expression of thoughts and feelings through words, by the control and manipulation of mind and hand, made permanent in the marks left by the simple tool which is the pen.

During the thousand years of the manuscript book and the five hundred of the printed book, letters have changed in dramatic and subtle ways. Until quite recently modifications usually came about slowly, for letters are essentially conservative (the letters on this page were developed and matured over a thousand years ago), their success measured by the skilfulness of the performance which produced them rather than by any radical treatment of their forms.

Tracing the alteration and changes in the appearance and use of written letters brings an understanding of the processes of historical movement, for letters often reflect, in the same way as other decorative and applied arts, the characteristics of particular places and times. Perhaps more important to artists and designers, the past is also a huge reservoir of visual ideas waiting to be discovered and reshaped to modern needs as well as providing a constant source of inspiration.

During the centuries following the death of Christ, the last centuries of the Roman Empire, the square capital letters of inscriptions were also used in books, although very few examples have survived. A narrower capital letter called rustic was also used in late Roman books, and the example shown here (Plate 1) was painted on a wall in the Italian city of Pompeii, destroyed in an earthquake in 79 AD. Elements of the square capital letters are also visible, and both square capitals and rustic capitals were revived several times in later centuries.

Square capitals and rustic capitals were, when written in books, almost always used for pagan texts. The early Christians appear to have deliberately developed a different kind of letter to distinguish or separate themselves from the old order. Uncial letters were used for four or five hundred years, and Christianity, with its commitment to the Word as revealed through a book, would have needed many books of different kinds.

An important feature of most early surviving books is that they were written on parchment manufactured from the pelts of animals — sheep, calf and goat being the most common. Parchment was used for books and documents almost throughout the Middle Ages, since paper, introduced into Europe by the Arabs, was rare until the fifteenth century. When properly prepared, parchment is very receptive to quill pens, prepared from the primary flight feathers of birds. The basic characteristic of the broad-edged pen is clearly visible in the examples of uncial shown here (Plates 3, 6, 7), a gradual transition from thick to thin marks as the broad-edged nib held at a constant angle described curves. This thick-to-thin mark is the basis on which the peculiar beauty and form of Western calligraphy and letters depends.

The writing material of classical times was papyrus, manufactured from the stems of plants which grew in the River Nile in Egypt. The late Roman cursive shown here (Plate 2), made with a blunt pen fashioned from the stem of a reed, was written on papyrus. The cursive script is not easy to read, since its letters are very different from modern forms. But it is beautiful for its sense of line and movement and, when married to more formal scripts, formed the basis on which the letters we still use were developed.

With the fall of the Roman Empire, learning was to become centred from the sixth to twelfth centuries in monasteries, and nearly all books created during this period were made in monastic scriptoria. The varieties of uncial script gave way to a range of local scripts, rarely calligraphically interesting. It was not until the early ninth century that, along with reforms of many other kinds, a single script was adopted throughout Europe. This style grew out of the powerful influence of Charlemagne (who at the height of his power ruled much of what is now modern Europe) and his churchmen. The new script, the Carolingian minuscule (Plates 8 and 10), was employed in highly organized books, and both the script itself and the way in which it was used have profoundly influenced writing and book-making ever since. A careful distinction was made between individual letters, and the use of small letters with capitals, but the effect of the script depended as much on the articulation of the space within the page, from the space between words and lines, to the larger margins which surrounded text areas.

Not for another three hundred years were other scripts to be developed. These grew from the demands made by new kinds of books and documents and are associated with the rise of urban centres (including universities) and the decline of monasteries. The twelfth-century script in the two monastic manuscripts in Plates 15 and 16 may not look very like the mature Carolingian minuscule in Plate 10, but it is essentially Carolingian with obvious differences of size, proportion and general aspect.

The varieties of late medieval scripts may best be seen in the specimen sheet of a German scribe and teacher of writing (Plate 20). An almost bewildering range of specimens are shown and each had its specific use, from formal books to commercial documents. For from the thirteenth century onwards numerous scripts were needed for bureaucracies and commerce. Records and transactions were, for the first time since late antiquity, systematically written down. With this growth in record-keeping came a need for suitable scripts and a large

number of scribes, for the typewriter was not to be invented until the nineteenth century.

During the later Middle Ages most lavishly decorated books were made for laymen or laywomen by urban-based professional scribes and artists. Plates 18 and 19 show two such manuscripts and both were written in the most formal of late medieval scripts. Curves were almost eliminated, and their effect depends upon the regular rhythm of black verticals and enclosed white spaces. The elimination of curved strokes may have been the result of streamlining production since it is easier to train a moderately skilled scribe to write letters composed of what are essentially straight lines than to form letters composed of thick-to-thin curved strokes. Manuscripts written in these kinds of scripts were especially appealing to Victorian tastes, and interesting parallels can be drawn between the weight of these letters and the bold letters used for ephemeral purposes in many nineteenth-century advertisements. Equally interesting are the visual parallels between late medieval script and modern sans-serif letters, the descendants of nineteenth-century display types.

Rather different in its effect but, like the two manuscripts shown in Plates 18 and 19, made in northern Europe, is the manuscript shown in Plate 23. Calligraphically, the vigour of the script is interesting and it has been adapted and used for some display work by modern scribes. It is, of all the late medieval bookhands, the most exotic in appearance and, unlike the script in Plates 18 and 19, has not yet become a visual cliché.

The manuscripts of the Italian Renaissance have been the most influential on printed books because they were perfected soon before the invention of printing from movable types. At a glance, without knowing that it was written, the fifteenth-century script in Plate 21 could almost be mistaken for printing, so close is its general appearance to the printed pages we are familiar with. The other great 'invention' of early printed books was the adaptation of a particular kind of script (with its origins in cursive scripts) now known as 'Italic' to accompany the 'Roman'. The script in Plate 21 is the ancestor of our Roman types and the compressed, pointed script in Plate 24 is the kind of script on which italic types were based.

The coming of printing obviously eliminated the need to write books by hand, although the printed and the manuscript book co-existed for about a hundred years, and the last manuscript books of the sixteenth century often closely imitated printed books in their letters. Over a period of about two generations there appears to have been a shift from a situation in which printed books imitated manuscripts to one in which manuscripts imitated printed works. The finest writing was by now usually to be found in documents, and especially in the hands of those who chose to write in an italic style, such as Bartholomew Dodington, an example of whose work is shown in Plate 28. The decision to write such a hand was taken not so much for its aesthetic or practical qualities, although italic is both aesthetic and practical, but because it was used by the most advanced humanists and scholars of the Renaissance. Other kinds of hands were written in the sixteenth century, and these descended from the myriad of late medieval scripts shown in the rather earlier specimen sheet of scripts in Plate 20 (see also Plate 27).

Gradually the range of scripts narrowed, so that by the end of the eighteenth century what is known as 'copperplate' or (in the United States) 'spencerian' was in use, with some local variations, throughout Europe. It was (and is) a script dependent for its effect on the pressure placed on the pen nib. Thick and thin strokes were not made with a broad-edged pen held at a constant angle, but by opening and closing the two points of a nib pressed hard or gently onto the paper. The technique was easily transformed into copperplate printing, in which plates were engraved, and the mutual influence of engraving and writing is very clear in the two late eighteenth-century examples of writing with printing shown in Plate 29.

At the end of the nineteenth century the Arts and Crafts movement revitalized many traditional crafts, including calligraphy. The typical Victorian 'illuminated' writing shown in Plate 30 shows how distant and remote the crafts of writing and illumination had become from their medieval predecessors. The concern of the great artist-craftsmen of the Arts and Crafts movement, of whom William Morris was the most seminal figure, was to try and restore artistic credibility to the work of craftsmen by reinvestigating the principles of the work of their medieval predecessors. Morris himself was interested in calligraphy and made some calligraphic manuscripts partly based upon his study of sixteenth-century writing manuals such as that of Arrighi, some of whose work is shown in Plate 24. Morris also collected medieval manuscripts, but the attention he devoted to calligraphy, lettering and type design was only one among a wide range of activities. The interest in formal writing and calligraphy that he inspired bore fruit in the work of Edward Johnston. Although Johnston worked after Morris had died, Morris's ideals were the foundation of Johnston's life work.

In 1906 Johnston published *Writing and Illuminating and Lettering*, the bible of calligraphers which has never since been out of print. Johnston's own work was to articulate clearly the importance of the broad-edged pen in fine writing, and early in his career he spent much time looking at, and analysing, medieval bookhands. Both the uncial reproduced in Plate 3 and writing from the Lindisfarne Gospels (Plate 5) were reproduced in his book with sharp observations on their character and structure. But it was the Anglo-Caroline hand reproduced in Plate 13 that interested him more, for he saw its fitness as a model and its suitability as a basis for individual development. Johnston's own work ran roughly the same course as medieval writing: early in his career he worked with uncial-type hands, later with Anglo-Caroline hands and, at the end of his career, with rather more compressed hands, similar in their general principles to late medieval bookhands. Johnston's best work has a taut elasticity and was rarely decorated except for variation of the size of letters and the use of red with black (see Plate 31). He also had a very fine sense of size and scale, which is difficult to see in reproduction.

Johnston's writings and designs had a wide influence, not only in England, but also in Europe. But while his work has a certain power of conviction and majesty about it, his followers in England mostly trivialized his teaching and output by failing to understand that he was primarily concerned with trying to establish principles. It was this concern of Johnston's that led him to design one of the most seminal of printed letters, the alphabet he created for London Transport (still in use), which profoundly influenced modern sans-serif type design.

Johnston's work was better understood in Germany, and there the teaching of lettering was less eclectic and more determinedly modern. The writing of Rudolph Koch (Plate 32) illustrates this perfectly, as a comparison of his work with the kind of writing on which it was modelled (Plates 17 and 18) reveals. Koch was very influential as a teacher and he also designed many typefaces.

Since the work of the pioneer scribes of the first part of the century, much of the most interesting work with texts and words has been made by painters. Two examples are shown here, one by Paul Klee, the other by David Jones (Plates 33 and 34). Their attitudes toward the text have been very influential in the last part of the present century, for the best work of modern scribes lays as much emphasis on the words themselves as on the manner in which they execute letters. Although a great deal of modern work is concerned with performance and the display of manual skills (dreary alphabets saying nothing, for example), anticipated only in part by the serious enquiry of such artists as Arnold Bank (Plate 35), the most interesting work is that in which content matters over and above execution.

The work of Ann Hechle (Plate 36) is not merely fine writing, but fine thinking about the nature and meaning of the words written. The large and elaborate piece shown here was considered over a period of years, and in it are to be found not only the results of her searching for suitable arrangements of her texts, but also their relationship to one another in what they say. The whole depends for its effect not only upon the scribe's skills but also upon her sense of content and rhythm (owing something to interval in the musical sense).

If the work of Ann Hechle is essentially verbal, that of Thomas Ingmire, in particular his recent output, is essentially visual (see Plate 40). Ingmire is no less concerned with the content of the words and texts with which he works than Hechle, but the richness of the painted surface and the integration of visual and verbal elements represents an interest which modern scribes and artists have only recently begun to explore. Different mixtures of attitudes toward the making of lettered pieces may be seen in the work of the two other modern scribes shown here, Susan Skarsgard and Charles Pearce.

The richness of the modern work shown here has not grown from nothing. It is rooted not only in a profound knowledge of the traditional tools and techniques of the scribe, but also in the eclectic, even iconoclastic, attitudes long held by modern artists which are new to scribes and those who use the texts of others as their subject-matter. More traditional work will continue to be made, but it is the recent movement toward expression rather than interpretation that is giving work written with pens its peculiar vigour and vitality. This is not a new thing, for centuries ago Eadfrith, the scribe and artist who executed the Lindisfarne Gospels (Plate 4) fused verbal and visual elements in his work. Few would deny that the Lindisfarne Gospels form one of the supreme works of art, and the best work of Eadfrith's modern successors is returning to his preoccupation with and concern for the apt presentation of the words of others.

No complete history of calligraphy and lettering can be revealed by the forty plates here. The selection is a personal one and includes some of the very finest work of the Middle Ages as well as some virtually unknown work which ought to be of interest to all those concerned with writing and lettering. If there is a bias, it has been toward English work which I (the author) know and love best. The format and size of this book has allowed much of the work to be shown at actual size, including the margins of pages. For ultimately the effect of writing does not depend on the manner of the execution of the strokes, whether made with pen, reed or brush, but on the spaces between them. It is the analysis of this, and the other formal elements that make up writing, which are the most useful to observe, for it is the principles to be discovered in the work of our ancestors which will best help us to understand it, and, most importantly, which will help us to see the world about us with new and better vision.

MICHAEL GULLICK

PLATE 1

Brush-drawn lettering from Pompeii. The small letters and the large letters at the top right are rustic capitals, and the large letters at the top left are quite close to the inscriptional capital letters of Rome but laterally compressed. Before 79 AD (much reduced).

DEDICATIONE

LVCRETI SATR

DIVI AEDI...

SPATIVM

QVINQVE

PLATE 2

Rapidly written Roman cursive script, using a reed pen, on papyrus. The letters may appear illegible to modern eyes, but they contributed to the forms of the small letters in use today. The line and movement in this piece of writing are close to some oriental calligraphy and modern drawing and have similarities with certain kinds of modern calligraphy (see Plates 37 and 40). 572 AD (slightly reduced).

PLATE 3

The arrangement of the lines, some long, some short, in this Gospel Book written on parchment, is by sense, and was intended to help the reader. Words are not divided, a feature of early books, and the script is a mature uncial. The sweetness of early uncial, detectable here, became lost over the centuries and the script became very artificial (see Plates 6 and 7). The pen-drawn initials were made by the scribe, and the E and A have carefully drawn split terminals, finished with hair lines made with the edge of the quill. The rather later correction on the left-hand page was rapidly written by a good scribe. Italy, sixth century.

INUENERUNTILLUM
INTEMPLOSEDEN
TEMINMEDIO
DOCTORUM
AUDIENTEMILLOSet *refaticanté*
INTERROGANTE

ILLOS
STUPEBANTAUTEM
OMNESQUIEUM
AUDIEBANT
SUPERPRUDENTIAET
RESPONSISEIUS
ETUIDENTESADMIRATI
SUNT

ETDIXITMATEREIUS
ADILLUM
FILIQUIDFECISTINOBISSIC
ECCEPATERTUUSETEGO
DOLENTESQUAE
REBAMUSTE
ETAITADILLOS
QUIDESTQUODMEQUAE
REBATIS
NESCIEBATISQUIAIN
HISQUAEPATRIS

MEISUNTOPOR
TETMEESSE
ETIPSINONINTELLE
XERUNTUERBU
QUODLOCUTUSEST
ADILLOS
ETDESCENDITCUMEIS
ETUENITNAZARETH
ETERATSUBDITUSILLIS
ETMATEREIUSCONSER
UABATOMNIAUERBA
HAECINCORDESUO
ETIHSPROFICIEBATSAPI
ENTIAAETATEET
GRATIA
APUDDMETHOMINES
ANNOAUTEMQUINTO
DECIMOIMPERII
TIBERIICAESARIS
PROCURANTEPONTIO
PILATOIUDAEAM
TETRARCHAAUTEMGALI
LEAEHERODE
PHILIPPOAUTEMFRA
TREEIUSTETRARCHA

PLATE 4

*The opening to Luke from the Lindisfarne Gospels, made about
698 at Lindisfarne off the Northumberland coast. The writing
and decoration of the manuscript are believed to be the work of
Eadfrith (Bishop of Lindisfarne 698–721). The page is
remarkable for the exactness of the execution (mostly made with a
pen over a preparatory layout) as well as for the articulation
and clarity of the verbal and visual elements. The different
kinds of letters, diminishing in size from the large Q, are typical
of the Irish (Insular) manuscripts of this period and this is a
device that was to be used throughout the Middle Ages. The
decoration, almost purely abstract, owes virtually nothing to the
classical world, and is especially appealing to modern
sensibilities familiar with non-figurative painting. A page of
writing from the same manuscript is shown in the next plate.
England, about 698.*

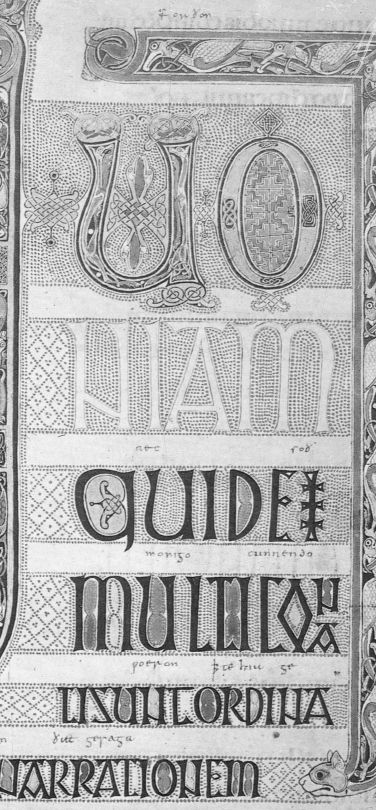

PLATE 5

A page from the Lindisfarne Gospels (see the previous plate). The sturdy, decorative script was developed in Ireland some centuries earlier, probably based upon an uncial-type letter with cursive elements. The interlinear gloss (the earliest extant English translation of the Gospels) was made about 950 in a highly skilled fluent hand which is as calligraphically interesting as the hand of Eadfrith. England, about 698.

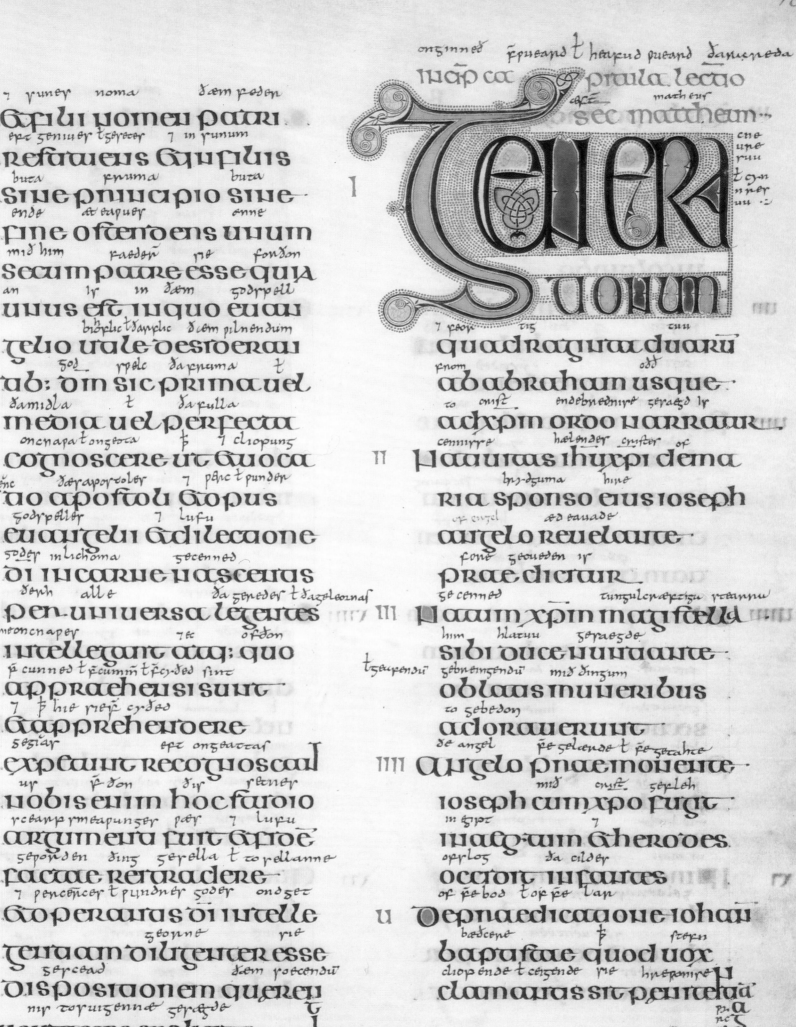

et fili nomen patri

reservens eius filiis

siue principio siue

fine ostendens uiuin

secum patre esse quia

unus est inquo euan

gelio uale desiderat

ubi dim sic prima uel

media uel perfecta

cognoscere ut euoca

uo apostoli opus

euangelii dilectaone

di incarne nascens

per universa legentes

intellegant atq; quo

apprehensi sunt

apprehendere

expediunt recognoscal

nobis enim hoc studio

argumentu fuit aptae

factae retractare

ad perfectas di intelle

gentiam diligenter esse

dispositionem querenti

noutacere explicit

incip̄ praefatio lectio
sec mattheum

TENER SUORUM

quadraginta duaru

ab abraham usque

ad xpm ordo narratur

Natiuitas ihuxpi dema

ria sponso eius ioseph

angelo reuelante

prae dicitur

Natum xpin magi stella

sibi duce nuntiante

oblatas muneribus

adorauerunt

Angelo praemonente

ioseph cum xpo fugit

in egiptum et herodes

occidit infantes

De praedicatione iohan

baptistae quod uox

clamatis sit praeterea

PLATE 6

The manuscript contains the Rule of St Benedict, the fundamental guide to monastic life for most of the Middle Ages. The manuscript is the only surviving example of the text in uncial letters as well as the oldest known copy of the text. There are no illustrations and the only decoration comes in the red titles and the black and red initials outlined with dots (an Insular practice, see Plates 4 and 5). The uncials are heavy in weight and there is little or no space between the words. The effect of the page, with its generous margins, wide space between the columns and generous interlinear space, is majestic. England, early eighth century.

XV ALLELUIA TENEATUR
QUIBUSTEMPORI
BUSDICATUR

A CO PASCHA
USQUEPEN
TECOSTEN
SINEINTERMISI
ONEDICATUR·AL
LELUIA·TAMIN
PSALMISQUAM
INRESPONSORI
IS·APESTICOSTEN
AUTEMUSQUE
INCAPUDQUADRA
GENSIMAEOM
NIBUSNOCTIB
CUMSEXPOSTE
RIORIBUSPSAL
MISTANTUMAD
NOCTURNASDICA
TUR·OMNIUERO
DOMINICAEXTRA

QUADRAGENSIMV
CANTICAAMATU
TINISPRIMATER
TIASEXTANONA
QUAECUMALLELU
IADICANTUR·
UESPERAIAMAN
TEFANA·RESPON
SORIAUERONUM
QUAMDICANTUR
CUMALLELUIA·
NISIAPASCAUSQ
ADPENTICUSTEN·
QUALITERDIUINA
OPERAPERDIEM
AGANTUR

UTAITPROFE
TA SEPTIES
INDIELAUDE
DIXITIBI·QUISEP
TINARIUSSACRA
TU NUMERUS

PLATE 7

A double-page spread from the Vespasian Psalter. The full-page illustration shows David with his scribes and musicians and is probably derived from Mediterranean models, although the frame and arch contain Insular motifs (see Plate 4). The initial D is followed by a line of rather dull letters against a lively coloured background, leading into the text. The script is a very expert late uncial, and the interlinear gloss was added in a good hand about a hundred years after the manuscript was made. England, second quarter of the eighth century.

XXVI · PSALM · DAVID · PRIUSQUAM LINIRETUR

DNS ILLVMINATIO

ET SALVS MEA QVEM TIMEBO·

DNS DEFENSOR VITAE MEAE A QVO TREPIDABO·

DVM APPROPIANT SVPER ME NOCENTES VT EDANT CARNES MEAS QVI TRIBVLANT ME INIMICI MEI IPSI INFIRMATI SVNT ET CECIDERVNT·

SI CONSISTANT ADVERSVM ME CASTRA NON TIMEBIT COR MEVM·SI INSVRGAT IN ME PROELIVM IN HOC EGO SPERABO·

VNAM PETII A DNO HANC REQVIRAM VT INHABITEM IN DOMO DNI OMNIBVS DIEBVS VITAE MEAE· TETAS·

VT VIDEAM VOLVNTATEM DNI ET PROTEGAR A TEMPLO SCO EIVS·

QVM ABSCONDIT ME IN TABERNACVLO SVO IN DIE MALO RVM PROTEXIT ME IN ABSCONDITO TABERNACVLI SVI·

IN PETRA EXALTAVIT ME·

ET NVNC EXALTAVIT CAPVT MEVM SVPER INIMICOS MEOS CIRCVIBO ET IMMOLABO IN TABERNACVLO EIVS HOSTIAM IVBILATIONIS CANTABO ET PSALMVM DICAM DNO·

EXAVDI DNE VOCEM MEAM QVA CLAMAVI AD TE MISERERE MEI·

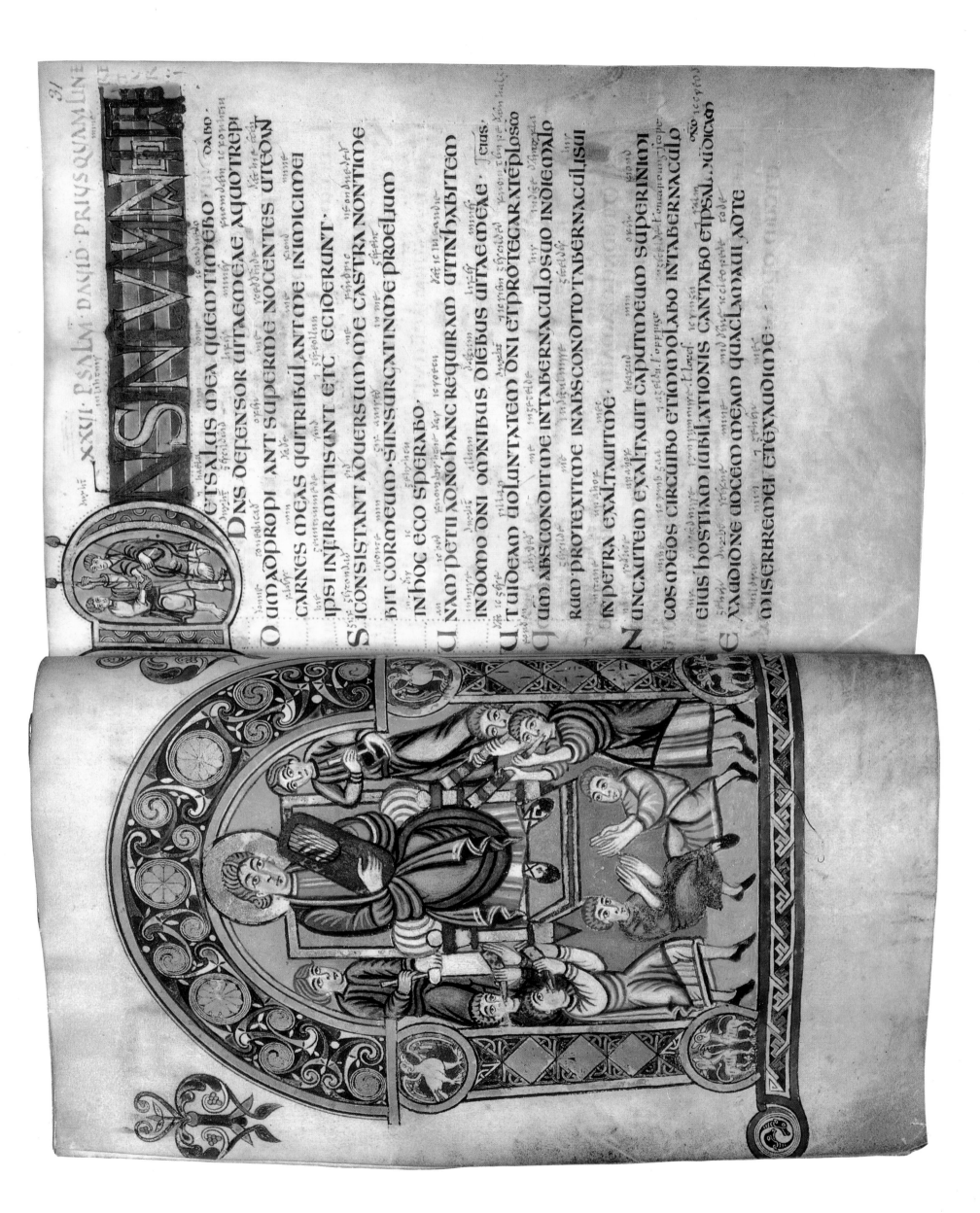

PLATE 8

The decorative letters made from fish, birds and animals have a certain vigour without being very imaginatively arranged. At the foot of the page the line of red capital letters is followed by two lines of uncials, and the text at the very foot is written in an early version of Carolingian miniscule that was to be perfected over the next thirty years (see Plate 10). France, about 800.

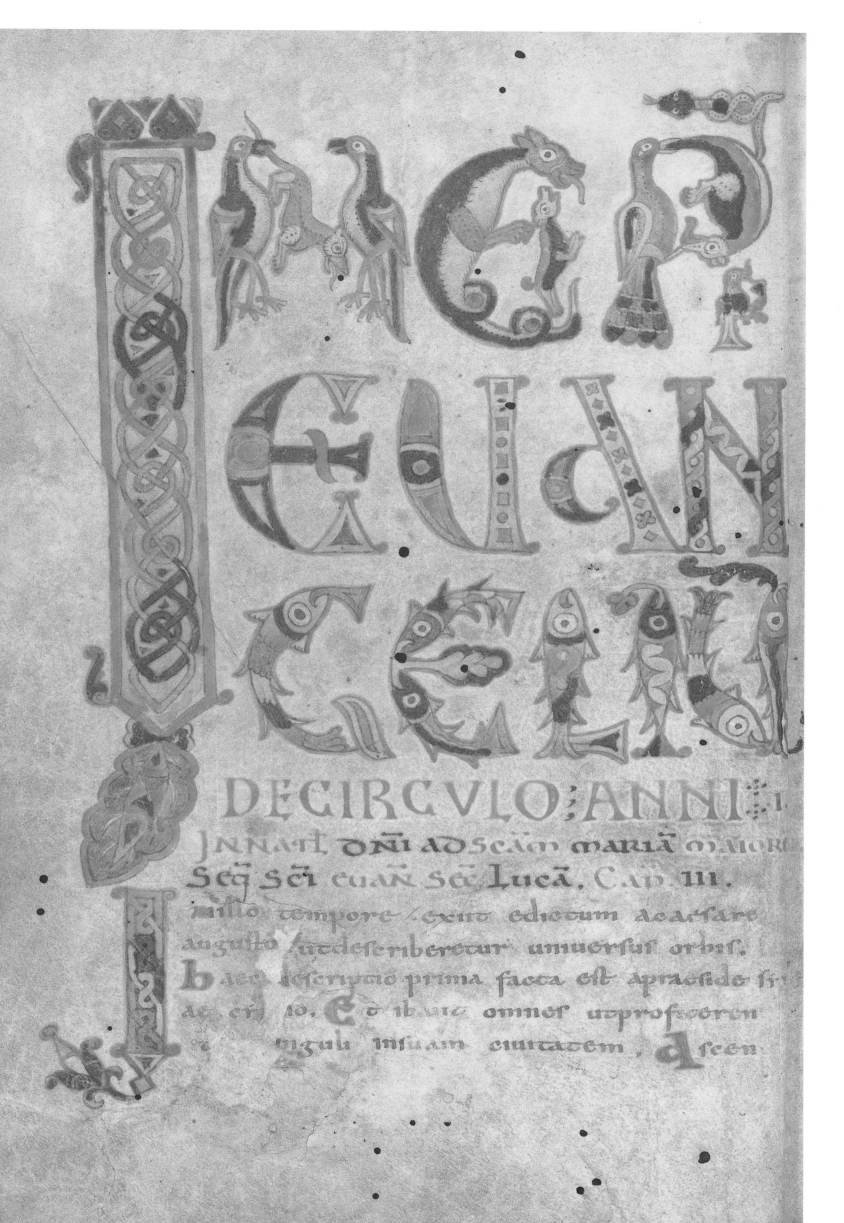

INCP
EUAN
CELI

DE CIRCVLO; ANNI: I

IN NATI DNI AD SCAM MARIA MAIOR
SEQ SCI EUAN SCI LUCA. CAP III.

illo tempore exiit edictum a caesare
augusto ut describeretur universus orbis.
haec descriptio prima facta est apraeside s
ae cir io. Et ibant omnes ut profiteren
nguli insuam civitatem. Ascen

PLATE 9

The opening words of Mark from a sumptuous ninth-century manuscript on stained parchment. The pen-drawn capitals are based upon classical inscriptional letters but for the initial I, almost entirely decorated with Insular interlace. The letters were outlined with a pen and were drawn within a frame with only the tail of the I taken outside it over the frame, emphasizing the otherwise flat page by creating a small illusion of three dimensions. France, early ninth century.

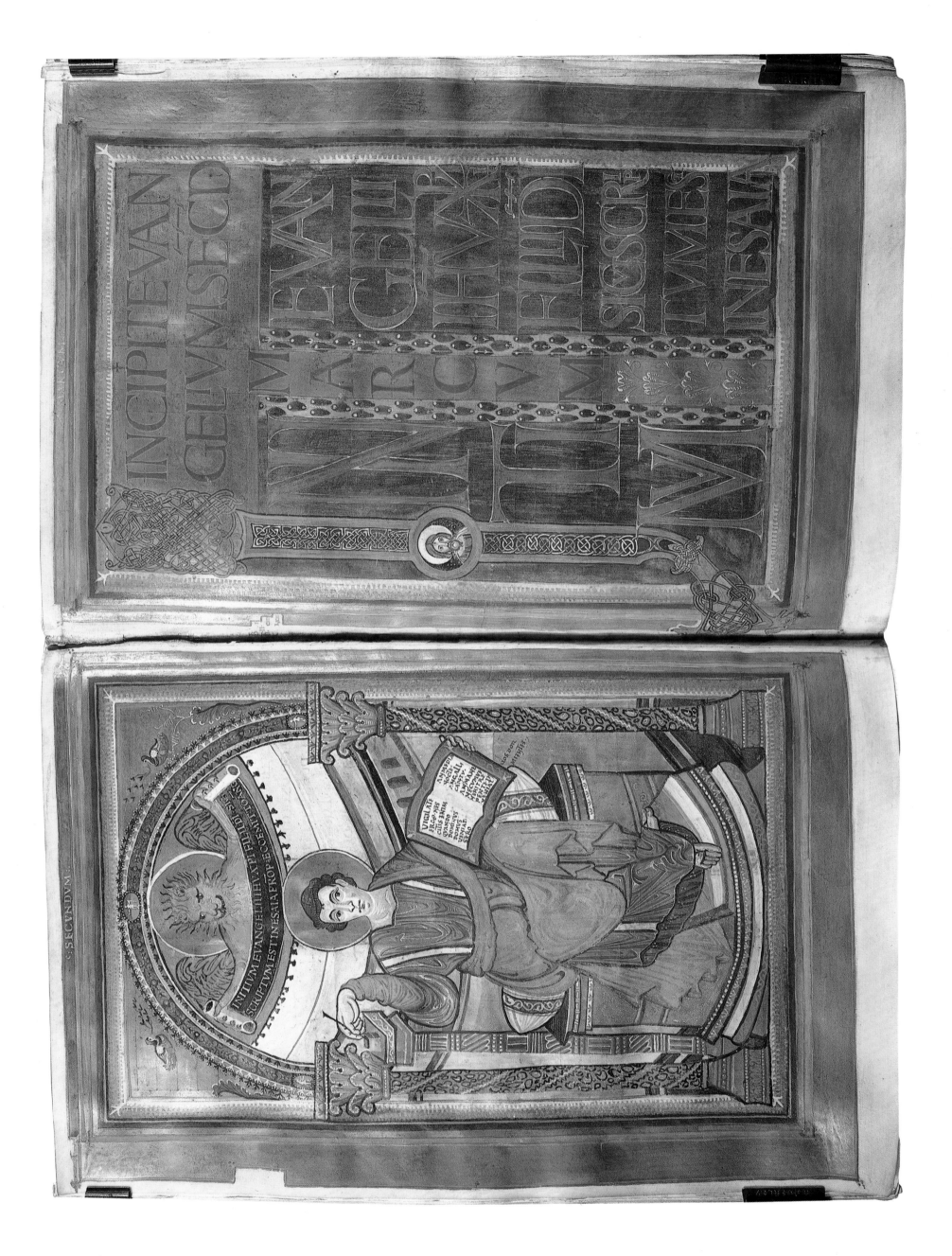

PLATE 10

The beginning of an Old Testament book from a huge ninth-century French Bible. The text is a fine Carolingian miniscule very close to the printed letters used today. The left column is the end of the chapter titles (a kind of contents list) and is concluded with a line of rustic capitals. At the head of the second column are two lines of capitals similar to inscriptional capitals, and following the initial D is a line of uncials. The clarity of the design of the page is striking, including the use of the running titles at the head. The figure in the initial D is reminiscent of classical figures, but the interlace in the stem is purely Insular. France, second quarter of the ninth century (reduced).

EXPLICIUNT CAPITULA

INCIPIT LIB
SAPIENTIAE

DILIGITE ius
titiam qui iudicatis
terram. sentite
de dno in bonitate
et in simplicitate
cordis quaerite
illum. Qni inue
nitur ab his qui non
temptant illum.
Apparet autem
eis qui fidem ha
bent in illum. per
uersae enim cogita
tiones separant a do. probata autem uirtus. cor
ripit insipientes. Qni in maliuola anima non in
troibit sapientia. nec habitabit in corpore sub
dito peccatis.

Sc enim sps disciplinae effugiet fictum et auferet
se a cogitationib; quae sunt sine intellectu. et cor
ripietur a superueniente iniquitate. Benignus e
enim sps sapientiae. et non liberabit maledictum
a labiis suis. Qni renum illius testis est ds et cordis
eius scrutator e uerus. et linguae illius auditor.
qni sps dni repleuit orbem terrarum. et hoc quod
continet omnia scientiam habet uocis. propter
hoc qui loquitur iniqua non potest latere. Nec
praeteriet illum. corripiens iudicium. In cogi
tationib; enim impii interrogatio erit. sermonu
autem illius auditio ad dm ueniet. Et ad correp
tionem iniquitatum illius. Qni auris zeli audit
omnia. et tumultus murmurationum non abscondet.

Custodite ergo uos a murmuratione quae nihil pro
dest. et a detractione parcite linguae. Qni sermo
obscurus in uacuum non ibit. Os autem quod
mentitur occidet animam. Nolite zelare morte
in errore uitae uestrae. Neq; adquiratis perditionem
in operib; manuum uestrarum. Qni ds mortem
non fecit. nec laetatur in perditione uiuorum.

Creauit enim ut essent omnia. et sanabiles fecit
nationes orbis terrarum. Non e in illis medica
mentum exterminii. nec inferorum regnum
in terra. Justitia perpetua e et immortalis. im
pii autem manib; et uerbis arcessierunt illam.
et aestimantes illam amicam defluxerunt.
et sponsionem posuerunt ad illam. Qni digni
sunt qui sunt ex parte illius.

PLATE 11

The interlace forming the Q from this large Psalter is typical of tenth-century Anglo-Saxon work, as are the animal head terminations. The coloured lines of pen-drawn capitals (the colours and colour sequence are possibly the house style of the scriptorium where the manuscript was made rather than the choice of the artist) diminishing in size down the page to two lines of rustic capitals, are as deliberate as the articulation of the elements in some of the earlier manuscripts shown here (see Plates 4, 8 and 10, for example) if less crisp in the density and richness of the elements. The lines of writing at the head of the page were written in a script looking like a cross between the script of the Lindisfarne Gospels (Plate 5) and Carolingian miniscule (Plate 10). England, last quarter of the tenth century (slightly reduced).

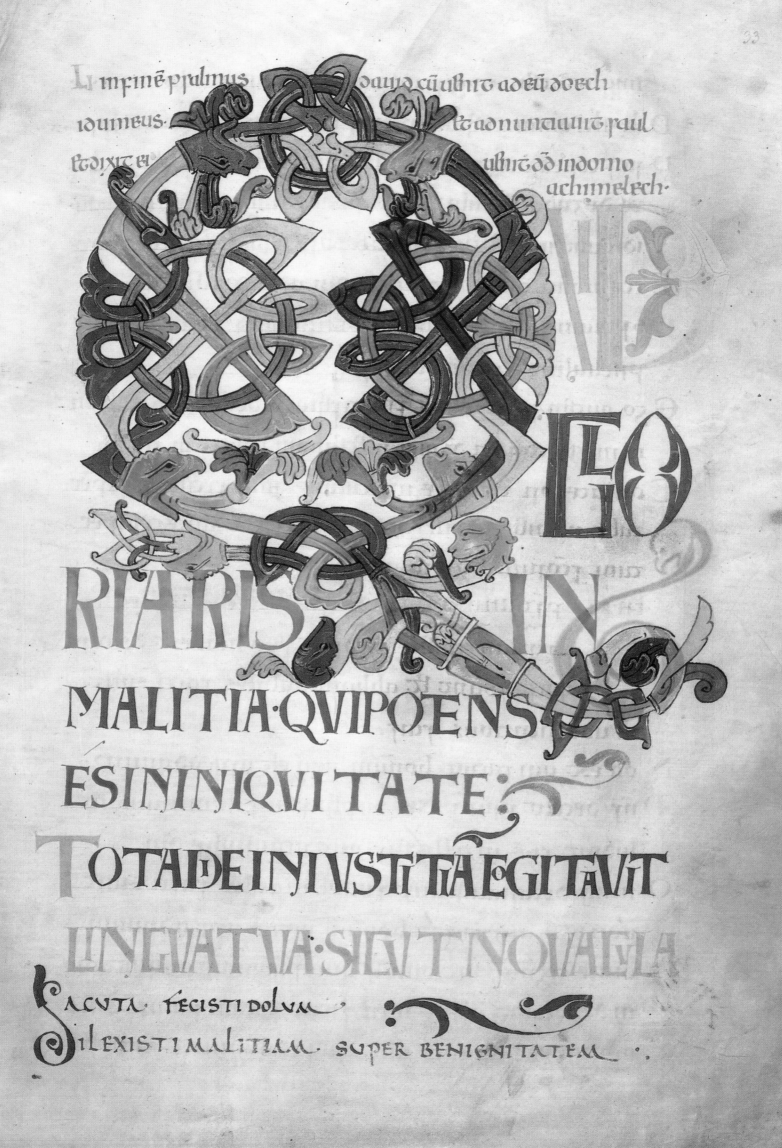

In fine psalmus david cu ustir ad eu doech
idumeus. Et adnuntiauit paul
Et dixit eu ustir ad indomo
achimelech.

EGO

RIARIS IN

MALITIA · QVI POTENS

ES IN INIQVITATE:

TOTA DIE INIVSTITIA COGITAVIT

LINGVA TVA · SICVT NOVACVLA

acuta fecisti dolum ·
dilexisti malitiam · super benignitatem ·

PLATE 12

The richly painted D from a Psalter is also typical in its design and structure of tenth-century Anglo-Saxon work (see also Plate 11). The acanthus leaves have a Mediterranean origin. The fine pen-drawn capitals (with a strong vertical emphasis) and the written rustic capitals lead the eye into the text. A page of writing from this manuscript is shown in the next plate. England, late tenth century.

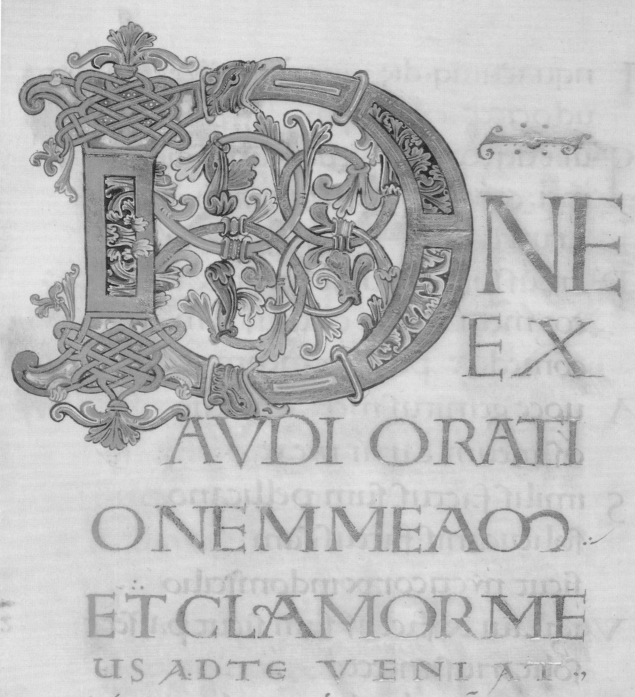

DNE
EX
AVDI ORATI
ONEMMEAM
ET CLAMORME
US AD TE VENIAT·
NON AVERTAS FACIEM TVA AME
IN QVACVMQVE DIE TRIBVLOR
INCLINA AD ME AVREM TVA·

PLATE 13

A heavy Anglo-Caroline miniscule was used in this Psalter, possibly to aid a reader when the text was read publicly. The hand is notable for its purity and the lack of calligraphic mannerisms. The character of marks made with a broad-edged pen held at a constant angle is especially clear in this example of writing. Although the hand is heavy, it is not in the least ponderous. The rhythm and pattern of the writing is slightly irregular, probably not deliberate but natural to the scribe. The hand is calligraphically famous, as Edward Johnston, the father of the modern calligraphic revival (see Plate 31 for some of his work), rightly recognized its capacity to serve as a basis for development of letter design. England, late tenth century.

amentabus te ·

Perfecisti eis qui sperant inte

inconspectu filiorum hominu ·

Abscondes eos inabscondito faciei tue;

a conturbatione hominum :·

Proteges eos intabernaculo tuo

a contradictione linguarum ·

Benedictus dns qm mirificauit

misericordiam suam mihi ·

inciuitate munita ·

Ego aut dixi inexcessu mtis meae ·

piectus sum afacie oculou tuoru :·

Ideo exaudisti uocem orationismeae ·

dum clamarem ad te :·

Diligite dnm oms sci eius: qm ueritate

requiret dns. & retribu& abundant

facientibus superbiam ·

Uiriliter agite & confort& ur cor

PLATE 14

Two leaves (of three) containing a collection of initial letters, partly drawn with the aid of drawing instruments and partly freehand over an underdrawing. If used in a manuscript, the initials would have been coloured with flattish areas of colour. The leaves were probably made to serve as a model or guide for others, including prospective clients, possibly by a professional artist. The leaves are the earliest of their kind to survive from medieval Europe. Italy, mid-twelfth century.

PLATE 15

The narrow proportion of the script here, roundish in its general aspect, is midway between the smaller Carolingian miniscule shown in Plate 10 and the angular compression of late medieval formal bookhands, as shown in Plates 17 and 18. The size of the manuscript and its two-column format are typical of twelfth-century monastic book production, and manuscripts like this were made in thousands all over Europe. This English example is known to have been written by a professional scribe and his hand is very smooth and fine. The superb B, almost entirely executed with a pen over an underdrawing, was made by another hand. England, mid-twelfth century.

an ū offendit in pncipū sene. s.
manserit ieo cui reposita mane
bant oīa. & ipse erat spes gentiū.
hinc ē suma exordiū.

(illuminated initial B)

Incipit lib. I
BEL
LO
PAR
Thi
co
Q̈d

ī̄ter omachabeos duces gen
temq; medox diuturnum ac
frequens uariaq; uictoria fuit.
incentiuū p̄cipuū dedit sacri
legiū dolor. q̄a rex antiochus
cui nom illustris. antiochi re
gis fili. ubi egyptū q̄q; suo
impio adiunxit. in supbiā
elatus q̄d ei incerta belloy
prospauissent. ritt hebreoy
negligi. ministeriaq; eoru
profanari iusserat. idq; po
stulantib; plerisq; iudeis sta
tuere ausus. Q̈d factū matha
thias sacerdos p̄peti nequiut.
nec solū ipse temp̄auit a
sacrilegio. regaliq; edicto n̄
obtēpauit uerū etiā immo

lantē simulacris hostias de
poptarib; suis nactus. gla
dio tr̄ī uerberauit: & congre
gata manu atq; assidens insō
a etate ascitis. ipse cū filiis
suis temerantes usū patriū
& iustitias legis. alios neca
uit. plerosq; expulit. belliq;
sabbato adoriendi auctor fu
it. ne simili arte ipsi q̄q; de
cēperē. sic iam plerisq; eorum
dum sabbato bellū suscipere
detrectant. irruentibz in se
hostibz multi occubuere. Po
tentiā p̄spi actus dederunt.
& p̄seuerauit in uiro usq; ad
exitū uite studiū defensionis.
& pietatis uigor. Sed cum
sibi sup̄mū diem ad. eē. intel
ligeret. uocatis ciuibz atq; as
sistentibz liberis: hortatus est
ut tuerent patriā templosq; re
ligionē. duceq; iis iudam ma
chabeū cure ac sollicitudinis
sue successore reliq̄t. q̄ bello
strenuus. consilio bonus. ac
p̄cerus fide. p̄mptus. q̄m fre
quenter innumeras hostium
copias parua manu fuderit.
p̄sequi n̄ est p̄sentis negotii.
q̄d tam breui colligere datur.
q̄d sepe p̄spis usus successibz.
excitauit in se magnā hostiū
multitudinē. q̄ artitus usu sun

PLATE 16

This leaf is the only one known to have survived from a manuscript probably broken up in the sixteenth century. Stained with age, it is an eloquent witness to the destruction of thousands of manuscripts following the dissolution of the monasteries in England. Its script is a little more idiosyncratic than the similar example shown in Plate 15, but many details are beautifully made with very firm strokes. The script of the two manuscripts has been little studied by modern calligraphers. Its beauty and presence is stunning and particularly clear here, where the effect of the script is uncluttered by any decoration. England, mid-twelfth century.

dum ē quia p se cadē potuerē sz
p se surgē ñ possunt atqz idō illi
impossibile ē do non ē sicut sep
tum ē spc uadens & ñ rediens &
de uia pditionis dictum ē qa os
qui ingrediunt p eam ampli non
rtutentur qa homo p se quidē ad
malū ire potest redire autem p se
ñ potest ñ p gram adiuuet & ad
iur sic ad penitentiā renouet ut
sic q intelligedū qd septū ī poßibi
le esse plapsos ad penitentiā reno
uari uelut pphicum illud q dic
tum ē uirgo isrt cecidit ñ adiciet
ut resurgat uirgo isrt Jn q simili
ter quidā a recta intelligentia er
rauerunt his ūbis conuenient ex
pressum quis dicat Ham qa scs
ieronim sup hunc locum quedā u
ba ambigua exposuit quidā qui
liberti ex scpturis materiam errouis
qm edificationis assumunt lapsos
reparari ñ posse conant astruere
Ait enim quia cum ds omnia pos
sit de corrupta uirginem facere
ñ possit Ipse uidit quid dicere uo
luerit ego a puritate fidi xptiane
ñ discedo Ueritas una ē Aplin di
centem audio Si aliud angts eu
angeratt anathema sit Ego ta
men sic sentio quia aliud dicere
uoluit etiam si ego nesciam qd di
ce uoluerit Sic tam pium ē sentire
ñ qa uerum dixit etiā si forte com
petenti uel euidenti dixisse potuis
set qd dixit Ego dictum catholici
uiri ad catholicam uiritatem intep
tari conabor Tam si de corruptio
ne carnis intelligitur hoc stul
tum ē sic sentire quia homo car

nem suā uiciare possit ds sanare ñ
possit Sz & si de corruptione cordis
hoc intelliget hoc similit stultū
dice qa ho peccare possit ds iutificare
ñ possit y tm iutificare qntu ille pec
care Si au iccirco illud ñ posse dr ds
quia factum ē ex quo factum y ñ fac
tum ēē ñ potest qa qd uerū y falsū ēē
ñ pot y iccirco ñ pot qa conū uiritate ñ
potest quia si conū uiritatem posset
conū se ipsum posset qui uritas ē qd
pondu habet hoc dictum magis qm
si diceetur de alio quolibet qd factū
ē & iam ñ ēē factum ñ potest etiā
si qd factum ē emdari potest ut
factum ēē ñ noceat qd factum est
Certum ē qa qui cadit resurgē po
test & ñ solum resurgē sz etiā me
lior resurgē qm fuit cum cecidit
Multi ceciderunt & meliores surre
xerunt qm fuert etiam antequm
ceciderunt meliores etiā qua futuri
ēēnt si ñ cecidissent quia ad hoc
ipsum cadē pmissi sunt ut ex ip
so casu suo & ruina erudirent y me
liores efficerent Hemo tm melior post
casū surrex Et resurgē potuit qm fu
isset etiam si ñ cecidisset & hec que
ñ resurgendo bona opatus ē om
nia stando opat fuisset Jn hoc satm
aliqd dici potest quia omnis qui
cadit id qd cadendo pdit ampli
totum recupare ñ potest qa quic
qd pea ad correctionem uel recu
pationem adiecerit face ñ potest
omnino qn melior fuisset si hec oia
haber & tam ñ cecidisset Propter
nemo in spe correctionis peccare de
bet quia qd semel amittit iam
pluus ipsum ñ recupat Qa qdqd

PLATE 17

The monumental late medieval bookhand shown here was produced by the almost total elimination of curved strokes. But see how the slight curvature to many of the smaller diagonal strokes relieves what would otherwise be a monotonous pattern. The dense, regular texture of the writing acts as a foil to the surrounding decoration which, despite being dazzling to the eye, was made to easily identifiable formulae ('colouring by numbers'). Some of the marginal figures are bizarre (known as grotesques), but the standing knight holding up a shield was no doubt connected to the manuscript's first owner, a member of a rich baronial family. The manuscript is a Psalter, as are the manuscripts shown in Plates 12, 13 and 18. England, early fourteenth century.

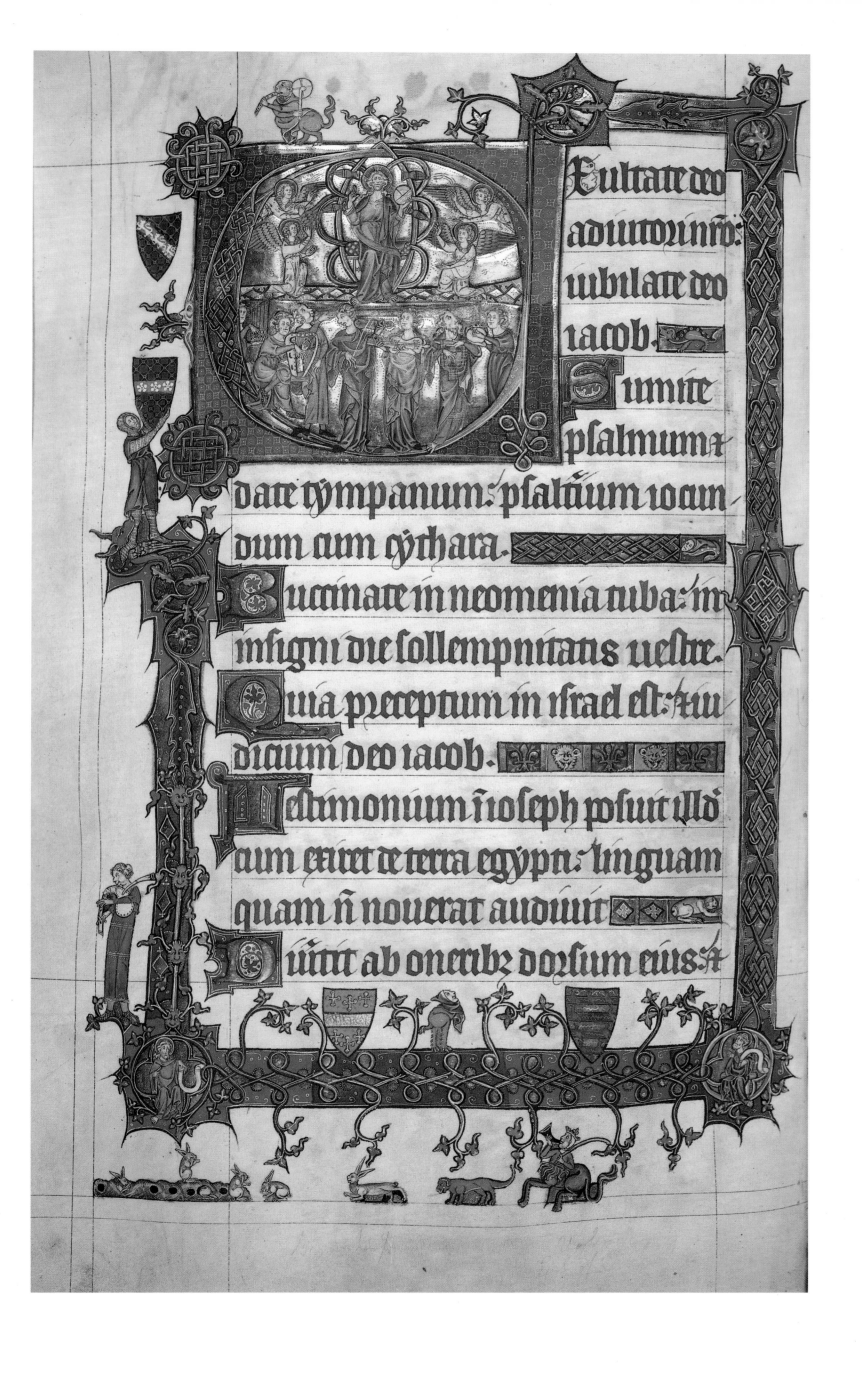

Exultate deo
adiutori nro:
iubilate deo
iacob.

Sumite
psalmum:
date tympanum: psaltium iocun
dum cum cythara.

Buccinate in neomenia tuba: in
insigni die sollempnitatis uestre.

Quia preceptum in israel est:/iu
dicium deo iacob.

Testimonium in ioseph posuit illd
cum exiret de terra egypti: linguam
quam ñ nouerat audiuit

Diuertit ab oneribz dorsum eius:/

PLATE 18

The hand in this plate differs from the similar hand in the previous plate in that the minims have square terminations at the feet. The fine lines used to finish many of the letters were made with the corner of the quill. The red pen work around the small initial letters was rapidly executed (possibly by a specialist) with great delicacy. The peculiar decoration, ranging from a carefully observed travelling carriage (other horses which pulled it are in the margin of the facing page) to the grotesques, is apparently quite unconnected to the text and used purely for ornamental purposes. England, about 1340.

tum nostrum

Recordatus est quoniam puluis sumus: homo sicut fenum dies eius tanquam flos agri sic efflorebit.

Quoniam spiritus pertransibit in illo ꝛ non subsistet: ꝛ non cognoscet amplius locum suum

Misericordia autem domini ab eterno: ꝛ usque in eternum super timentes eum

Et iusticia illius in filios filiorū: hiis qui seruant testamentum eius.

Et memores sunt mandatorum ipsius: ipsius: ad faciendum ea.

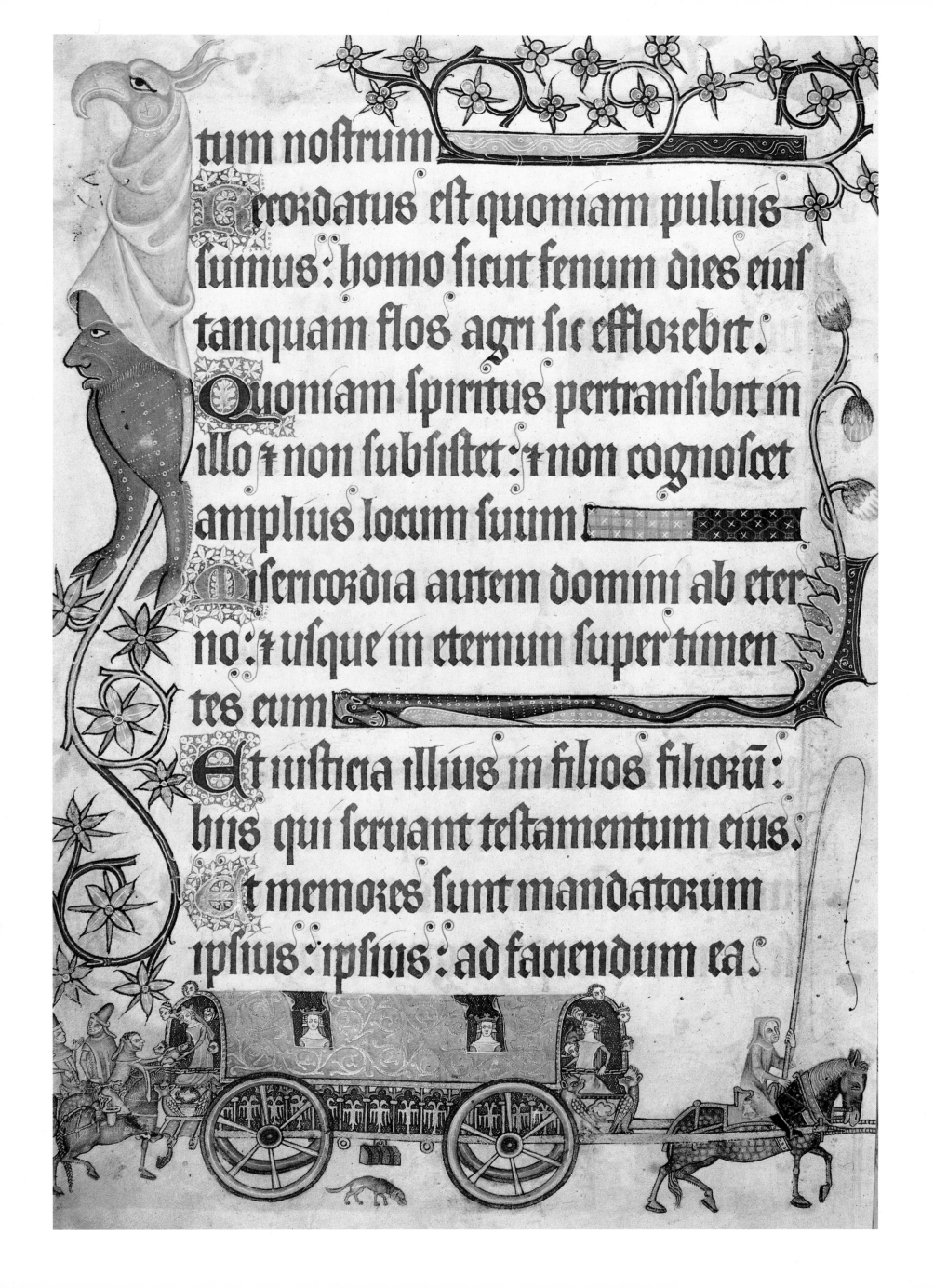

PLATE 19

The diagram shown here occurs in the middle of a religious poem in an enormous manuscript containing a vast collection of English poetry. The first column gives the petitions of the Lord's Prayer (in Latin) with an English translation in the roundels underneath. The piece then has to be read horizontally with the petitions leading, through the maze of decorative panels, to columns listing, first, religious truths, secondly, the virtues, and, at the right, the vices. The content and format are typical of religious thought and attitudes during the late Middle Ages, here brilliantly realized in visual form. England, late fourteenth century (much reduced).

Per petiones — vn Dona the — vn vn Vtutes — Contra — vn Vicia

	Peticiones		Dona the			Vtutes	Contra	Vicia
	Pater noster qui es in celis sanctificetur...		Timor dni			Humilitas		Superbia
			Drede of god			mekenesse And lownesse		Pride & tolbnesse
	Adueniat regnum tuum		Pietas			Caritas		Inuidia
			Pite of his tresbore			loue & charite		Enuie
	Fiat voluntas tua sicut in celo et in terra		Sciencia			Pax		Ira
			knolech & witt...			Pes & reste & pete		Wrathe & angur
	Panem nostrum cotidianum da nobis hodie		Fortitudo			Vigilancia spiritual		Accidia
			strengthe a...					Slowthe
	Et dimitte nobis debita nostra...		Consilium			Pauptas spir...		Auaricia
			Counsel...					Couetise
	Et ne nos inducas in temptacionem		Intellectus			Mensura	Sobreta	Gula
			vndur stondi...			mesure & mete and sobrinesse & drinke		Glotonie
	Sed libera nos a malo Amen		Sapiencia			Castitas		Luxuria
			Sauour & likig...			Chastite & clennesse		lecherie

Per petiones serviuntur ad dona p dona ad virtutes & virtutes sunt contra vicia

PLATE 20

A sheet of various scripts shows vividly the many different styles which were in use during the late Middle Ages. The sheet would have been displayed in a public place to advertise the work of its scribe-teacher. The passage at the lower right declares that all those who wish to be instructed in different styles of writing should come to the scribe Johann van Haghen, who assures potential students that they will be able to learn quickly and for a fair price. (Germany, about 1400 (reduced).

Beatus vir qui non ab= | abiit in consilio impi= | orum et in via peccato= | rum non stetit et in cathedra

Verba mea auribus | percipe domine intel= | lige clamorem meum | Intende voci orationis mee

Notula — Notula simplex

(text in Gothic cursive, largely illegible)

Notula acuta

(text in Gothic cursive, largely illegible)

Semi quadratus — Semi quadratus

Cum invocarem exaudivit me | deus iustitie mee in tribula= | tione dilatasti michi Miserere | mei et exaudi orationem meam

Textus Rotundus

Quare fremuerunt gentes et populi | meditati sunt inania Astiterunt | reges terre et principes convenerunt | in unum adversus dominum et adver=

Notula — Notula fracturarum

(text in Gothic cursive, largely illegible)

(lower left text block, Latin — Psalm 50 Miserere — largely illegible)
... mei deus secundum magnam misericordiam tuam ... secundum multitudinem | ... miserationum tuarum dele iniquitatem meam ... lava me ab in= | ... mea et a peccato meo munda me Quoniam iniquitatem meam ...

Argumentum

(text in Gothic cursive, largely illegible)

Notula glauata

(text in Gothic cursive, largely illegible)

Argumentum extra pennam

(text in Gothic cursive, largely illegible)

PLATE 21

This large Renaissance manuscript is quite different from the late medieval books of northern Europe (Plates 17 and 18). The small script was based upon earlier models to revive the clarity of such Carolingian books as shown in Plate 10. The modern look to the letters is due to the fact that some early printers based printing types on script like this — the direct ancestors of the letters you are now reading. A great deal in this page owes much to the past and the perception that Italian Renaissance scribes, artists and patrons had of classical Rome. The lines of capital letters at the head of the page and the carefully constructed large initial G reflect the proportions of Roman inscriptional letters. The dense border is a mixture of flat, decorative motifs pierced by little pictures receding away from the surface plane of the page. Italy, mid-fifteenth century (reduced).

AVRELII AVGVSTINI DOCTORIS EXIMII DE CIVITATE DEI LIBER PRIMVS FELICITER INCIPIT.

LORIOSISSIMAM CIVITATEM DEI
SIVE IN HOC TEMPORVM CVRSV CVM
inter impios peregrinatur ex fide uiuens siue
in illa stabilitate sedis aeternae quam nunc expe
ctat per patientiam quoad usq, iustitia conuerta
tur in iudicium deinceps adeptura per excellentia
uictoriam ultimam & pacem perfectam hoc opere
ad te instituto & mea ad te promissione debito de
fendere aduersus eos qui conditori eius deos suos p
ferunt fili carissime marcelline suscepi. Magnum
opus & arduum sed deus adiutor noster est. Nam scio quibus uiribus opus sit
ut persuadeatur superbis quanta sit uirtus humilitatis qua fit ut omnia terre
na cacumina temporali mobilitate nutantia non humano usurpata fastu sed
diuina gratia donata celsitudo transcendat. Rex enim & conditor ciuitatis hu
ius de qua loqui instituimus in scriptura populi sui sententiam diuinae legis ape
ruit qua dictum est. Deus superbis resistit humilibus aut dat gratiam. Hoc ue
ro quod dei est superbe quoq, animae spiritus inflatus affectat amatq, sibi in lau
dibus dici Parcere subiectis & debellare superbos. Vnde etiam de ciuitate terre
na quae cum dominari appetit & si populi seruiant ipsa ei dominandi libido do
minatur non est pretereundum silentio quicquid dicere suscepti huius operis ra
tio postulat & facultas datur. Ex hac nanq, existunt inimici aduersus quos de
fendenda est dei ciuitas quorum tamen multi correcto impietatis errore in ea fiut
satis idonei multi uero in eam tantis exardescunt ignibus odiorum tamq, mani
festis beneficiis redemptoris eius ingrati sunt ut hodie contra eam linguas non
mouerent nisi ferrum hostile fugientes in sacratis eius locis uitam de qua super
biunt inuenirent. An non etiam illi romani christi nomini infesti sunt quibus
propter xpm barbari pepercerunt? Testantur hec martyrum loca & basilice apo
stolorum quae in illa uastatione urbis ad se confugientes suos alienosq, receperut.
Hucusq, cruentus seuiebat inimicus ibi accipiebat limitem trucidatoris furor illo
ducebantur a miserantibus hostibus quibus etiam extra ipsa loca pepercerant ne
in eos incurrerent qui similem misericordiam non habebant qui tamen etiam
ipsi alibi truces atq, hostili more seuientes postea q ad loca illa ueniebant ubi fue
rat interdictum quod alibi iure belli licuisset tota feriendi frenabatur imma
nitas & captiuandi cupiditas frangebatur. Sic enaserunt multi qui nunc xpianis

PLATE 22

It is possible that this manuscript was written and decorated by the same hand, an unusual occurrence in the late Middle Ages and early Renaissance. Certainly the scribe of the manuscript was Bartolomeo San Vito of Padua, who spent a long period of time working in Rome. His pen-written coloured capital letters, based on late Roman inscriptional letters, are very distinctive, especially the A and V which always appear to lean slightly backwards. The two lines of writing at the foot are in San Vito's informal script and appear almost to have been 'drawn' rather than written, so carefully were the individual letters spaced out. The surface of the flat page is broken by the miniature, but all the visual elements, lettering, miniature, initial and frame lie harmoniously together. The cutting of the tail of the Q in the initial and its placement under the letter is a gentle, humourous touch. Italy, 1497–1499.

P·VIRGILII MARO
NIS GEORGICON
LIBER·I·
AD MECAENATEM·
VID FAC
AT LAE
TAS SE
GETES·
QVO SIDERE TERRÃ

Vertere mecænas·ulmisq, adiungere uites
Conueniat·quæ cura boum·qvis cultus halendo

PLATE 23

This page, from a manuscript of one of the most lavishly illustrated copies of a popular chivalric romance, is made up from a number of quite distinct elements, as were the Italian pages in Plates 21 and 22. It is dominated by the large miniature which appears as a window into a distant and remote world inhabited by figures whose sole preoccupation was pleasure. If it appears like that now, this is also how it would have appeared to its contemporaries. The flat border, with carefully observed natural life depicted, encloses the whole, not only the miniature but also the rather dull initial and an area of writing. The script is called bâtard and is a curious mixture of formal and informal elements. It is very clearly pen-made and calligraphically interesting for its powerful sense of touch. Low Countries, about 1490 to 1500 (reduced).

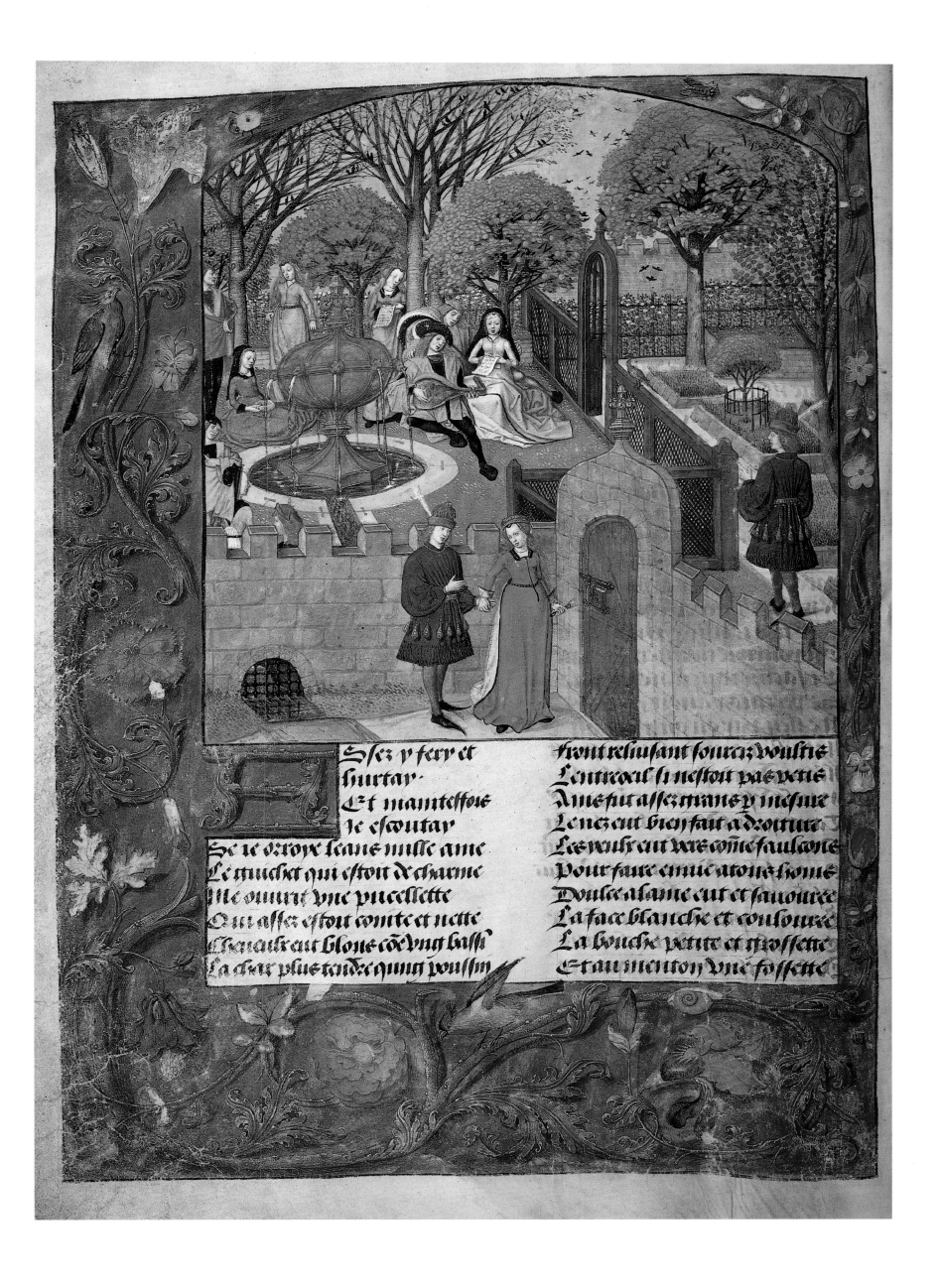

sses y ferv et
surtay.
Et maintesfois
le escoutav
Se ie ozope seave mille ame
Le touchet qui estoit de charme
Ille ouvrit vne pucellette
Qui asses estoit comte et nette
Se chevaulx eut blons côe vng bassi
La chair plus tendre qui vng poussin

front reliusant souvez voulstis
Lentreœil si nestoit pas vetis
Avespit assez mansy mesure
Lenes eut bien fait a droiture
Les veulx eut vrc côme faulsône
Pour faire enuie atoure sione
Doulse asame eut et sauouree
La face blanche et coulouree
La bouche petite et grossette
Et au menton vne fossette

PLATE 24

This manuscript was made in Italy for presentation to King Henry VIII. It was almost certainly written by Arrighi, a scribe who worked in the Papal Chancery and who is famous as the author of the earliest illustrated printed writing manual. The manual taught the student what has become known as italic and this is the hand used in the manuscript shown here. Italy, about 1509 to 1517.

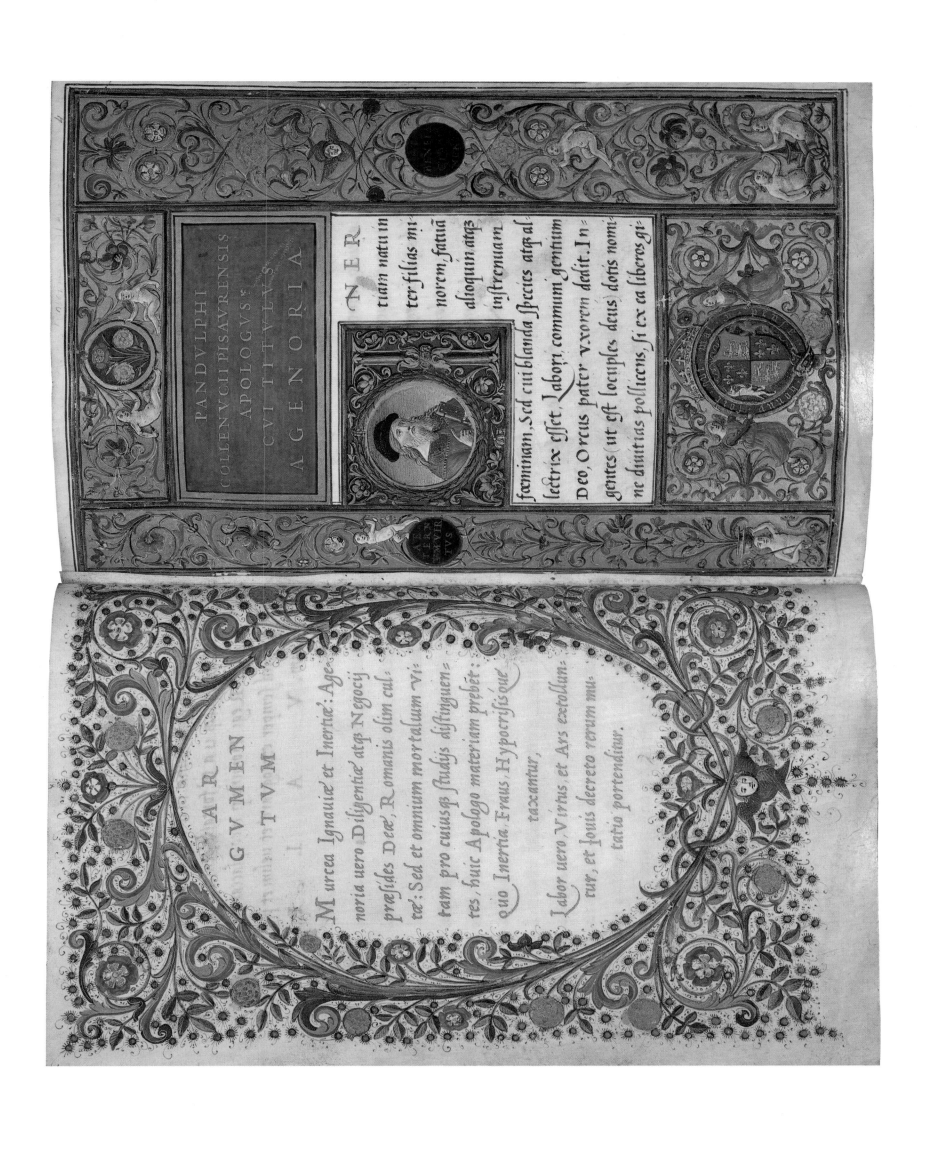

PANDVLPHI
COLLENVCII PISAVRENSIS
APOLOGVS.
CVI TITVLVS
AGENORIA

N E R tiam natu in
ter filias mi
norem fatuã
adhoquin atq;
instremiam
fœminam, Sed cui blanda species atq; al
lectrix esset. Labori, communi gentium
Deo, Orcus pater vxorem dedit. In
gentes (ut est locuples deus) dotis nom
ne diuitias polliccns, si ex ca libros gi-

ARGVMENTVM

Murcea Ignauiæ et Inertiæ: Age=
noria uero Diligentiæ atq Negocij
præsides Deæ, Romanis olim cul=
tæ: Sed et omnium mortalium vi=
tam pro cuiusq studijs distinguen=
res, huic Apologo materiam præbet:
quo Inertia Fraus, Hypocrisisque
traducuntur,
Labor uero Virtus, et Ars extollun=
cur, et Jouis decreto rerum mu=
tatio portendatur.

PLATE 25

A double-page spread from a manuscript which contains a number of decorative letters. The alphabet shown here is made entirely with the pen and the delicate flourishes surrounding the letters were also drawn directly with the pen. The purpose of the manuscript, like the similar, slightly later manuscript shown in Plate 27, is unclear but it appears more likely that it is a record made to preserve the styles of its letters rather than to provide models. The manuscript appears to be signed and dated and the name of the artist-scribe was Johann Holtman. Another spread from the manuscript is shown in the next plate. Germany, probably 1529.

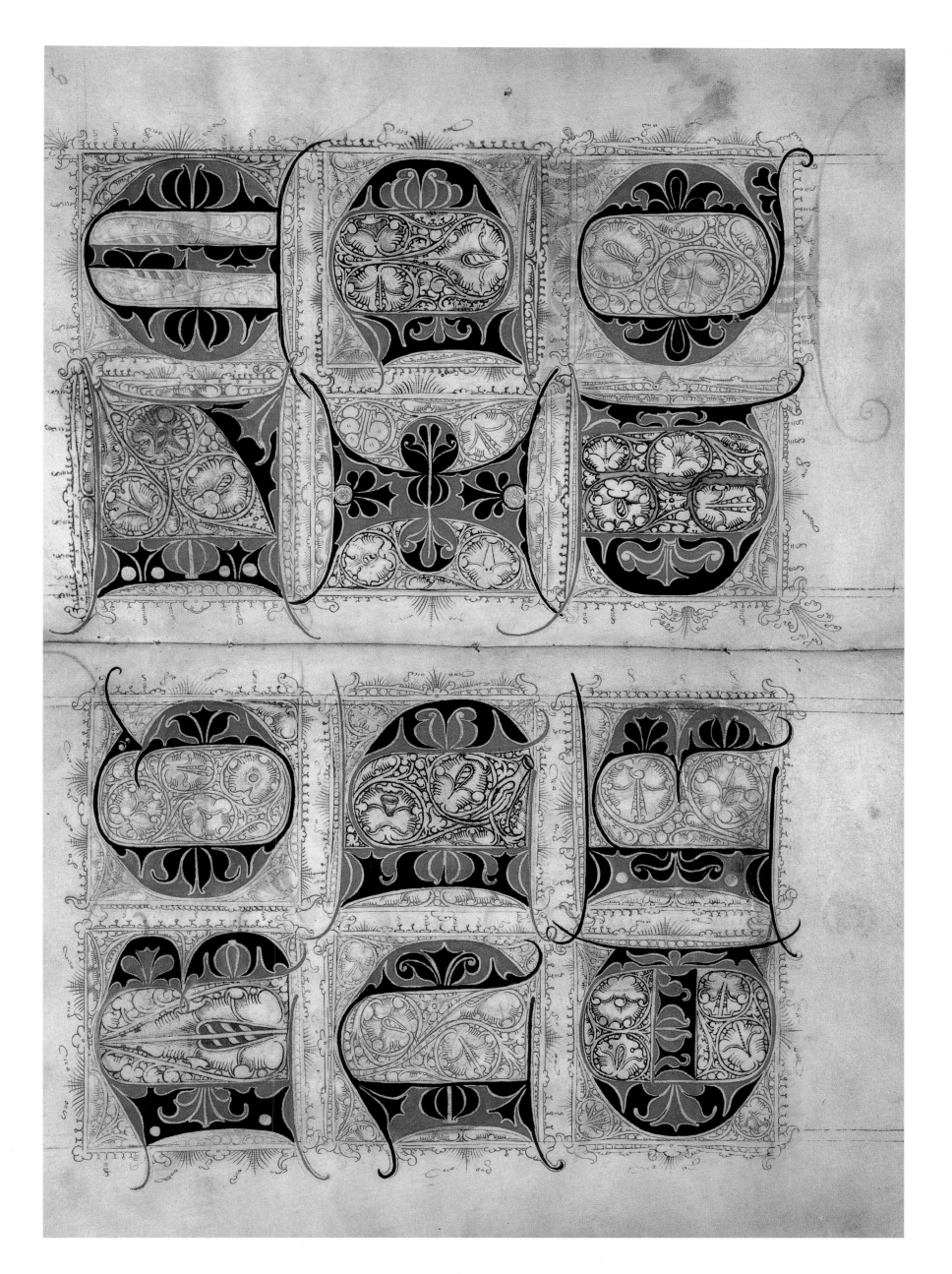

PLATE 26

Unlike the spread from the same manuscript shown in the previous plate, the alphabet here is largely pen-drawn except for the simple pen-written letters. The washed drawings surrounding the letters are very delicate in their execution. Germany, probably 1529.

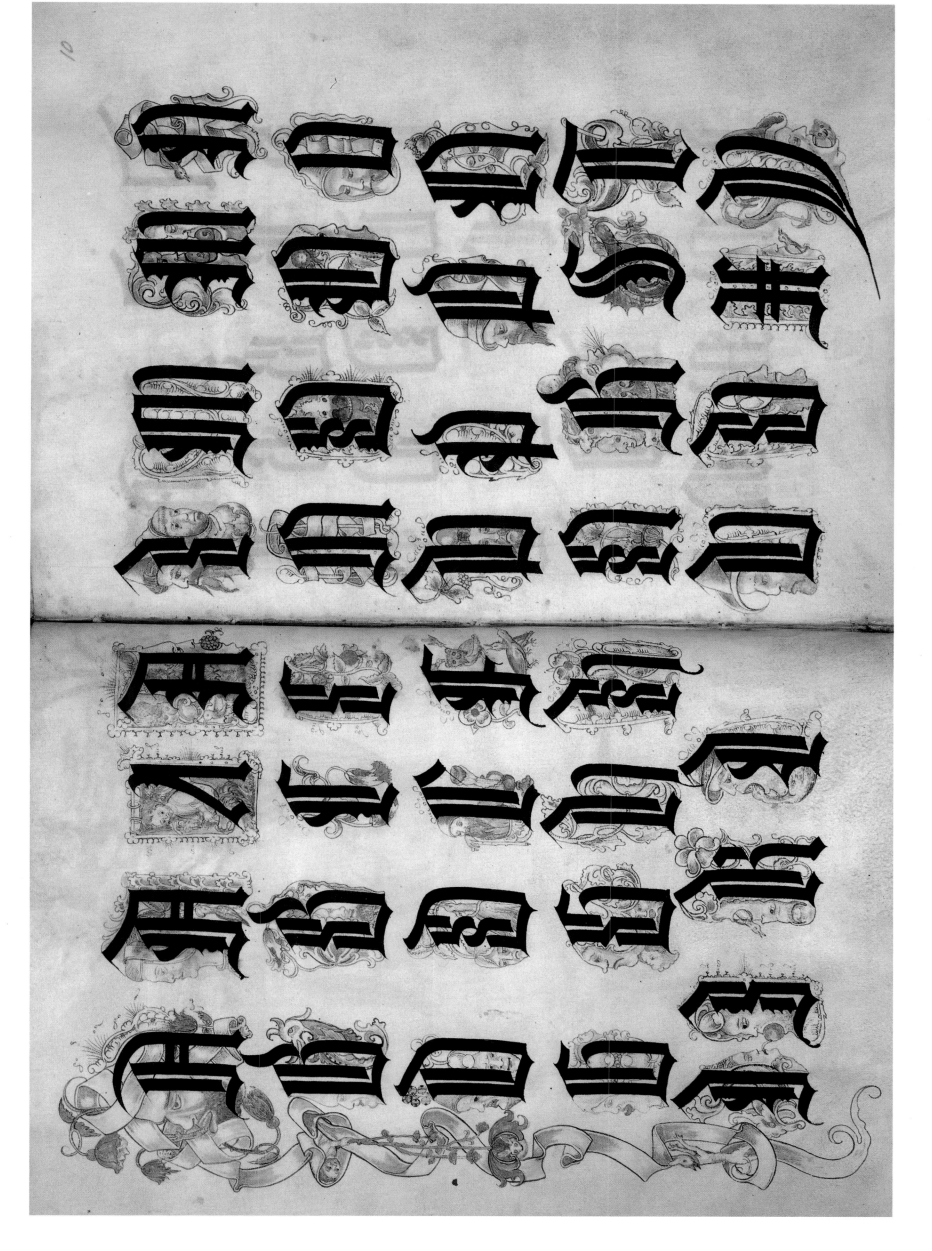

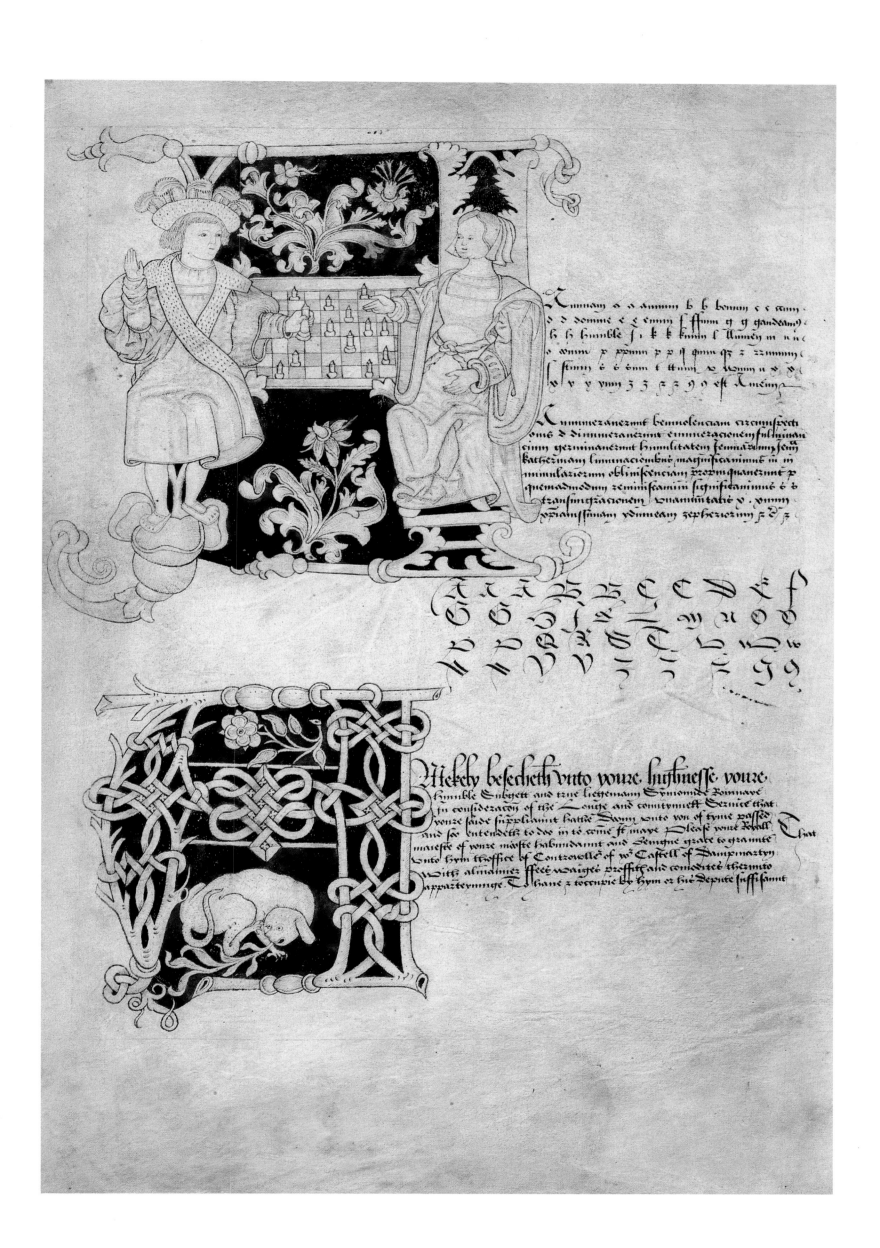

PLATE 28

The script written by many educated people during the sixteenth century was italic (see Plate 24). This example – a letter – was written by one of the finest sixteenth-century writers of italic in England, Bartholomew Dodington of Cambridge. Written with a finely cut pen (the script is virtually monoline) with immaculate control, the lettering is almost ethereal it is so perfect. But there are enough small delicate touches to relieve the regularity and some final, discreet flourishes underneath the signature. England, 1590.

Cum benignitatis tuæ erga me ex quo me primum in patrocinium tuum recepisti
tanta magnitudo sit, Honoratißime Domine, ut eidem nullis officijs meis, nedum
exili hoc scribendi genere queam satisfacere: non committerem hoc tempore, ut tam levi
munere defungens, auribus tuis potius, quæ gravißimis reip. causis patere solent, conarer
obstrepere, quam tacita recordatione beneficiorum tuorum memoriam celebrarem;
nisi talis oblata eßet occasio, qualem prætermittere sine scelere vix poße viderer. /
Detulit enim ad me iampridem scilicet patre, nuper autem benignissimo patrono orbatus,
filius fratris mei, se cum supplex tecum ageret de Locatione illarum ædium renovanda,
quas ei pater suus Westmonasterij reliquit, à te responsum quidem perliberale abstulisse,
sed tale duntaxat, ut cum me habitare in eisdem intelligeres, fontem beneficentiæ tuæ
mihi magis, quàm illi aperueris. Reliquam etiam significationem summæ erga me
benevolentiæ tuæ sermone subsequebatur: quam ego nullis meis meritis vel præteritis,
vel expectatis evocatam, grata animi memoria, & omni observantia, quoad vixero,
colam. Sepenumero etenim in aurem insusurrans vox illa Theognidis valde hanc
labem vitandam esse monet: Δειλους ὁ ... φροντι μεταφοραιν Χρις εστιν. Ισον και
ευ̉ειρᾳν τουτον αλος πολιης. Sed quæ eße omnino gratia poterit, quæ à me profecta
tantam assequi Dominationis tuæ bonitatem queat! aut quid denique gratuita bene-
ficentia tua præter se spectat! quæ in summo splendore quasi maioribus theatris pro-
posita, non usque eò se sustinet, quoad precibus (quod fero plerisᵹ usuvenit) exorari poßit:
sed ipsa se mihi offert ultrò, et quodammodo ad petendum allicit. Quid igitur! oblatamne
conditionem tam benignè solus ipse verecunda quadam recusatione amittam? At
dixerit aliquis fortasse: Μισω σοφιστὴν, ὁστις ου̉χ αυτῳ σοφος. Ego verò cum in hoc
ipso facile Prudentiæ tuæ probavero, mihi pietatis potius erga cognatum fratris filium,
quam proprij commodi ducendam eße rationem, tum illi vel soli delatum hoc quicquid
erit beneficij ut vtrique commune à tua beneficentia profectum, non agnoscam solum,
sed profitebor etiam libenter. Quo nomine gratulor sanè utrique nostrum: eße scilicet
et summa facultate qui poßit, & egregie propenso animo qui velit, nostræ
seorsim solitudini ac inopiæ suis temporibus subvenire. Sed illa scilicet & fuit
iampridem, & deinceps erit semper gratulatio mea maior, quod communis patriæ hijs
difficillimis temporibus quasi in vigilia quadam consulari manes, eandemᵹ in tanta
orbitate spe magna sustentas. Quæ ut quàm diuturna sit magnopere omnibus est
expetendum, mihiᵹ iuxta cum alijs vota indies facienda pro tua longa incolumitate, &
honoris amplificatione, proposui, ut pergas porro communi saluti sic operam navare, ut
præteritorum prosperis progressibus, felices etiam futurorum exitus respondeant. /
Westmonasterij XII. Calend. Maij. 1590.

Honori tuo deditißimus, ~
Bartholomæus Dodingtonus

PLATE 29

The variety of scripts that existed in the late Middle Ages (see Plate 20) gradually became reduced and narrower in range. The two examples of writing here, from the late eighteenth century, show the contrast that existed between the hands of clerks and highly wrought printed letters (engraved and printed from copper plates) and charming headpieces. For much of the century, the teaching of writing had been and was to continue to be directed, as the books and advertisements of the teachers tell us, to those who worked in business and commerce. The Industrial Revolution demanded huge amounts of paperwork, all needing to be written out by hand. Fine writing was certainly a useful social grace but by now very much a minor one, which, however, perfectly reflected the spirit of its times. England, 1781 and 1791.

Now the gentle GALES

Fanning their Odoriferous Wings Difperfe

Native Perfumes,&whifper whence they ftole

Thofe balmy Spoils.

Richard Warren, PERFUMER,

at the Golden Face in Mary le Bone Street

London

Imports, Makes & Sells

London 12 May 1781.

Bot of R. Warren.

3 Bot.s Mk Mk Roses — 10. 6
2 D.o Efsence of Musk — 1. —
10.o Oil of Jefsamine — 8. —

£ 1. 2. —

Rec.d at the same time the contents

KING'S.

Bot of Thomas King, William King & Co.

MERCERS to his MAJESTY.

near Royal Highnefses the Prince of Wales, Prince Frederick, Prince's Royal &c&c

At the Wheat Sheaf & Sun, King Street Covent Garden, London

Ray'd June 25 1791

PLATE 30

Two pages from an illuminated address in book form, made in Birmingham in 1891. With its medieval-style borders and letters, and a highly wrought miniature, mostly if not entirely painted with a brush, the work is enormously skilled. Its lack of aesthetic credibility and misdirected endeavour does not entirely detract from its period charm. It is very representative of the nadir of the 'Gothick' style, which was a seminal influence on the decorative arts and industrial design of the Victorians. England, 1891 (reduced).

We the undersigned Past and Present Students of the Birmingham School of Medicine, and other members of the Medical Profession, feel that we cannot let pass the occasion of your resignation of the post of Honorary Physician to the General Hospital without

Sir Walter Foster: K.B.
M.P., M.D., F.R.C.P.,
Senior Professor of Medicine in
Queen's College, Birmingham,
Consulting Physician to the General Hospital,
West Bromwich Hospital,
Kidderminster Infirmary,
Ear and Throat Hospital,
Skin and Lock Hospital,
Member of the
General Medical
Council.

LABORE ET VIRTUTE

PLATE 31

A broadside with the opening lines of Chaucer's The
Canterbury Tales, *written by Edward Johnston in 1927.
Johnston later described the piece for an exhibition label in a
typical manner: 'Written on Vellum with a Broad STEEL
NIB (*ground sharp *by the Scribe), and — the Notes — with a
fine cut TURKEY'S QUILL, April 1927. "INKS": Oxford
Ochre & Gum & Ivory Black and Vermilion: the Rubricated
Writing in Orange Vermilion and Gum. This Manuscript is an
attempt to reproduce (in an exaggerated Size) an archaic form of
writing for the sake of its decorative Value & its contemporary
Value (it synchronises with the poem). There is a loss of*
Modern Legibility *which would debar it for many purposes,
but is here unimportant. The Rubricated Notes were thrown in
(by the Scribe) for decorative value & interest & to help the
Setting E.J. 19 Feb. '36.' England, 1927 (reduced).*

Here biginneþ þe Book of þe Tales of Caunterbury.

Whan þat Aprille Wiþ his shoures sote ,

Þe droghte of Marche haþ perced to þe rote ,

And baþed euery veyne in Swich licour ,

Of Which vertu engendred is þe flour ,

Whan Zephirus eek Wiþ his sWete breeþ ,

Inspired haþ in euery holt and heeþ ,

Þe tendre croppes and þe yonge sonne ,

Haþ in þe Ram his halfe cours yronne ,

And smale foWles maken melodye ,

Þat slepen al þe night Wiþ open ye ,

So prikeþ hem nature in hir corages ,

Þan Longen folk to goon on pilgrimages ,

Geoffrey Chaucer (c. 1340–1400. A.D.) wrote these words about 1386. A.D. probably at Grenwich
(as conjectured by Skeat, pp. xvij & xiij). They are here transcribed in a free copy of an English Book Hand of about 1380. A.D.

" The Prologue as given by Skeat
Here biginneth the Book of the Tales of Caunterbury .
WHAN that Aprille with his shoures sote
The droghte of Marche hath perced to the rote ,
And bathed every veyne in swich licour ,
Of which vertu engendred is the flour ;
Whan Zephirus eek with his swete breeth
Inspired hath in every holt and heeth
The tendre croppes and the yonge sonne
 Hath in the Ram his halfe cours y-ronne ,
 And smale fowles maken melodye ,
 That slepen al the night with open yë ,
 (So priketh hem nature in hir corages):
 Than longen folk to goon on pilgrimages "
{ " ... and specially .. to Caunterbury ...}

Though in its size the writing is about four times as tall as the
1380 Book Hand (in Chaucer's time the twelve lines might have
been written in a space of about five square inches), yet the shapes
of the Letters may be taken as somewhat like the characters in
which the Tales must first have been written in a Book.
The text is taken from Skeat's "Student's Chaucer" (1897) ~ v. opp.~
but his punctuation is omitted and replaced by line-end marks
and certain letters are changed in form to the contemporary
usage : thus þ = th , ſ = s (initial or medial) , but
final s = s , and u ſ = u. or v. (medial or final), but
initial u. or v. = v .

Þ Belue lines hir late Scriueyn for to yelde ,
Edward a scribe , by ordre of þe yelde ,
In nineteen hundred tWenty seuenþ Aprille ,
Wrote out Wiþ yren and Wiþ foWles Quille.

For presentation to Miss Louisa Puller this is written for the Society (or Gilde) of Scribes & Illuminators by me E.

PLATE 32

The German craftsman-scribe Rudolf Koch wrote astonishingly vigorous gothic hands but in an inimitable manner, and his work rarely looks anachronistic. The expressionist pen work is entirely in the spirit of post-World War I German art, yet the text is the Gospel of Matthew. Germany, 1921 (slightly reduced).

Der nun sah, daß er von den Wasser vertragen
war, ward er froh zumut und schüttete aus und
ließ alle Kinder zu Erd schleuben und aus ist
der ganze Greis... ...zu sweien weg und drin
ter waren ward er Acht sie er mit Acht von
Den werde er ...Sache, auf der Kiste das
Bezak ... von deinem... ...Beklug weg
Fürcht... Auf dem Gebirge, wo man ein Ge-
höre geboren ...iel Kindert, weineten und wol
[etwas] Rachel beweinte ihre Kinder und wol
te sich nicht trösten lassen, denn es war aus mit
einer. Aber derohalb begebens geschehen, und
erfüllet der Engel das ... von dem ...bey ich
ar dem ...igt ordentlich und ...eine Mutter:
Stehe auf und nimm das Kindlein und seine Mutter
mit dir und zeuch hin ins Land...
...sprach, daß ...kommen und gehen und
sich ...Sag dich... aus in ...
... er... ...ommen und ...des Fluch
...ugt und ...land... in den Ort
... von deinem Land ...und wohnt
in der Stadt ...

Sie sind geboren an die Sünde nach dem Leser ...Jeder
nahm auf und nahm das Kindlein, und ... zu sich und kam in
... sein ...

...nehme es und ...in ...
... ...spricht
...wonne ...
...undauf das
... ...
...trug ...des Fluch und...
...und ...auf ...
...und ...und ...auf das
...und ...und ...zu Haus...
...und ...und das
...und ...auf ...
...und ...und

...ist sie aber Haus weggezogen von
... der Engel des ...den
...und sprach: Streck auf und
nimm das Kindlein und seine Mutter zu dir...
...und ...land und ...so lange
...und ...und ...daß sie
...und ...und der ...
...und ...undZunge
...und ...auf ...zu Haus...
...und ...und ...und...

Trauen, daß sie nicht wieder sollten zu Freude
werden und zogen durch eben und durch weg
wieder in ihr Land.

PLATE 33

'Einst dem Grau der Nacht enttaucht'

The text of this watercolour is a mystical poem describing, with particular and general images, beginnings and growth (and perhaps endings too). Not always easy to read on the level of either comprehension or visual decipherment, Paul Klee's painting is verbally and visually dense. The monoline letters and the colour changes, and the underlying quasi-geometric structure delicately express feelings and moods grounded in the verbal imagery. Switzerland, 1918.

Bahn

Einst dem Grau der Nacht enttaucht / Dann schwer und teuer / und stark vom Feuer /
Abends voll von Gott und gebeugt // Nun ätherlings vom Blau umschauert, / entschwebt
über Firnen, zu klugen Gestirnen.

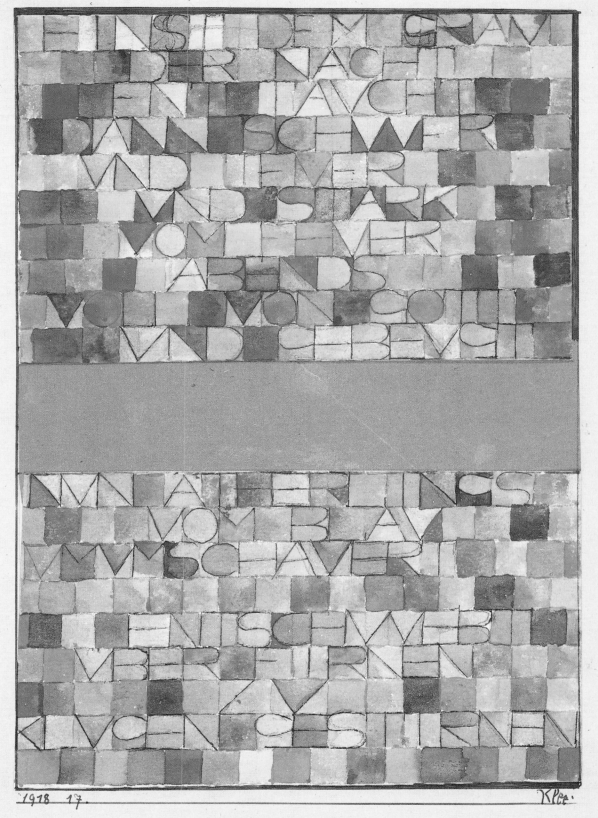

1918 17. Klee.

PLATE 34

'Pwy Yw R Gwr'

A design by David Jones for an inscription to be painted on a chapel wall, this is the largest of the artist's lettered paintings and the one he considered the most important. The upper passage, alternately Welsh and Latin, is an extract from a fourteenth-century poem by the Welsh poet Gruffud Gryg with Latin translation. The lower passage is from the Latin Canon of the Mass with Welsh translation. England, 1956 (reduced from 590 × 770 mm).

PWY·WY·WR·GUR·PIA·VR·GOPON
QVIS·EST·VIR·QVI·HABE·CORONAM
D·WWYN·A·FRATH·DANE·FRON
DEVS·CANDIDVS·VVLNERAT·VSS·VBPECTORE

HOSTIAM+PVRAM·HOSTIAM+SANCTAM
ABERTH·PVR·ABERTH·GLAN
HOSTIAM+IMMACVLATAM
ABERTH·DI·FRYCHEVLYD

PLATE 35

'Rose's Onion'

The work of the American calligrapher–artist–teacher Arnold Bank has an enormous reputation although little of it has been published. Bank was fascinated by letters of all kinds and made many paintings and drawings of letters, usually alphabets or collections of letters rather than texts. His work was based upon a sound and wide knowledge of historical forms and at its best, as here, has a compelling poetry about it. United States, 1957 (reduced from 387 × 552 mm).

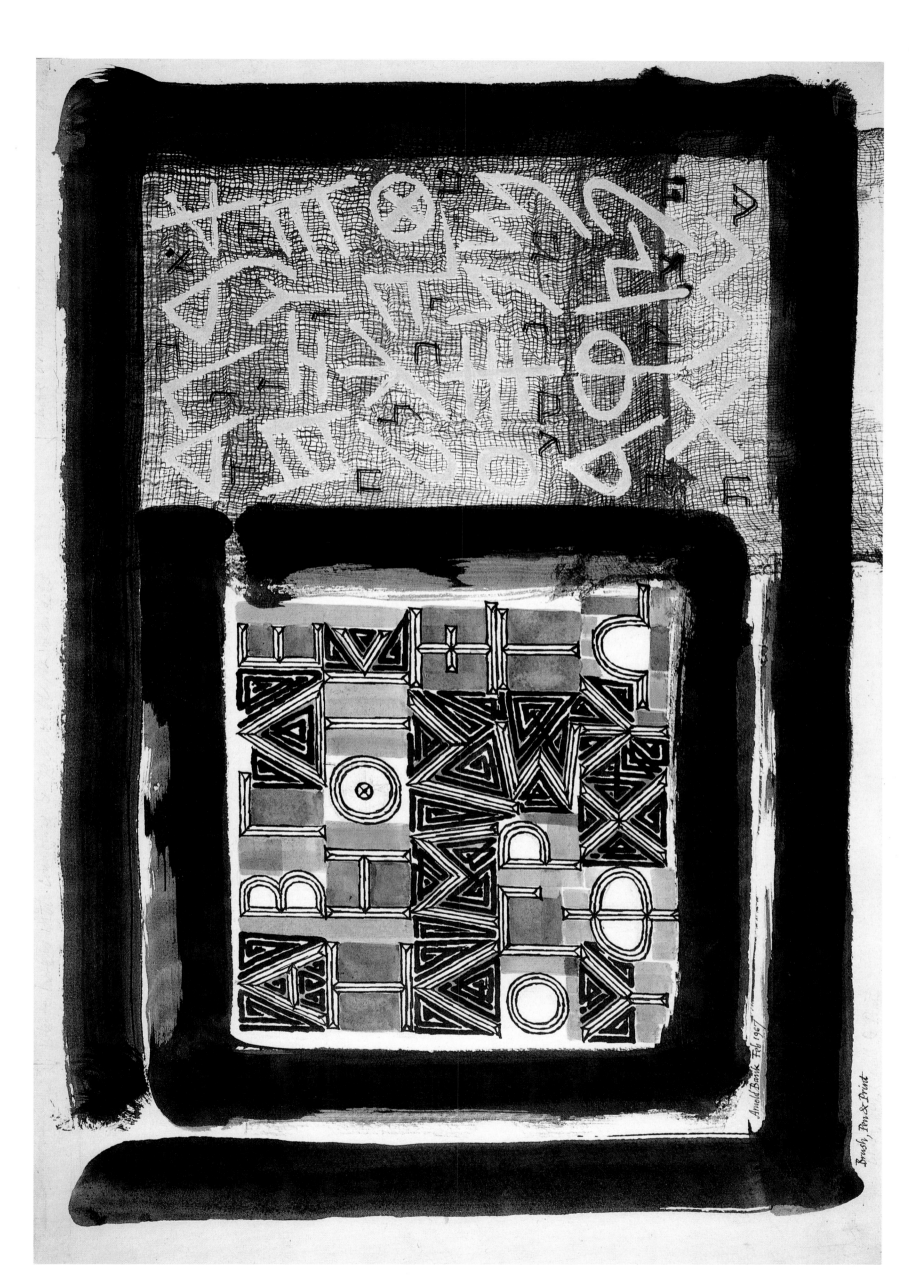

Arnold Bank Feb 1967

Brush, Pen & Print

PLATE 37

'Writing is the optical version of speech'

The piece was made as a poster for a lecture given by the designer and scribe Susan Skarsgard concerning her study experience with the Austrian calligrapher–teacher Friedrich Neugebauer. The text is from one of Neugebauer's books. United States, 1988 (reduced from 648 × 381 mm).

all letters were signs at first.
all signs were first pictures.

writing is the optical version of speech

every movement
as spiritual ac-
tion has its own
adequate sign.
writing is order
& is the means
to higher un-
derstanding.
†neugebauer

Friedrich Neugebauer is an internationally acclaimed calligrapher, graphic designer and teacher, as well as, author of The Mystic Art of the Written Forms - a beautifully written and illustrated handbook for lettering. His career has spanned over 50 years, not only producing manuscript books and broadsides, but also designing books and book jackets, typefaces, urban signage syste s, advertising and corporate identity programs.

 In May of last year, five calligraphers from the United States and Ireland were priviledged to study with Professor Neugebauer in an intensive seminar at his studio/home in Austria. Among those invited to this extraordinary experience was Ann Arbor calligrapher, Susan Skarsgard.

Susan is a lettering artist with Curley Campbell & Associates in Southfield and is editor/designer of Quill, the Journal of the Michigan Assoc. of Calligraphers. Her work has been published and exhibited widely including Print Regional Design Annual 1986-87, Scarab Club Advertising & Art Exhibition 1987, and Calligraphy Review 1988.

Detroit/AIGA will sponsor a slide/lecture on the Neugebauer experience by Susan Skarsgard on Wed., April 27th at 7pm at the Baldwin Library in downtown Birmingham, 300 W. Merrill, 647-1700. $3.00 donation for non-Detroit/AIGA members.

Design/Calligraphy: Susan Skarsgard Printing: The Hamblin Company Color Separation: SFC Graphic Arts Paper: Butler Paper Type & Production: Curley Campbell & Associates

PLATE 38

Romeo and Juliet

One of a series of panels, each devoted to a Shakespeare play, by the English born scribe Charles Pearce who now lives in America. Pearce is one of the finest writers *of modern times and his letters are based upon an intimate knowledge of historical forms freely interpreted and adapted for present needs. United States, 1989 (reduced from 698 × 457 mm).*

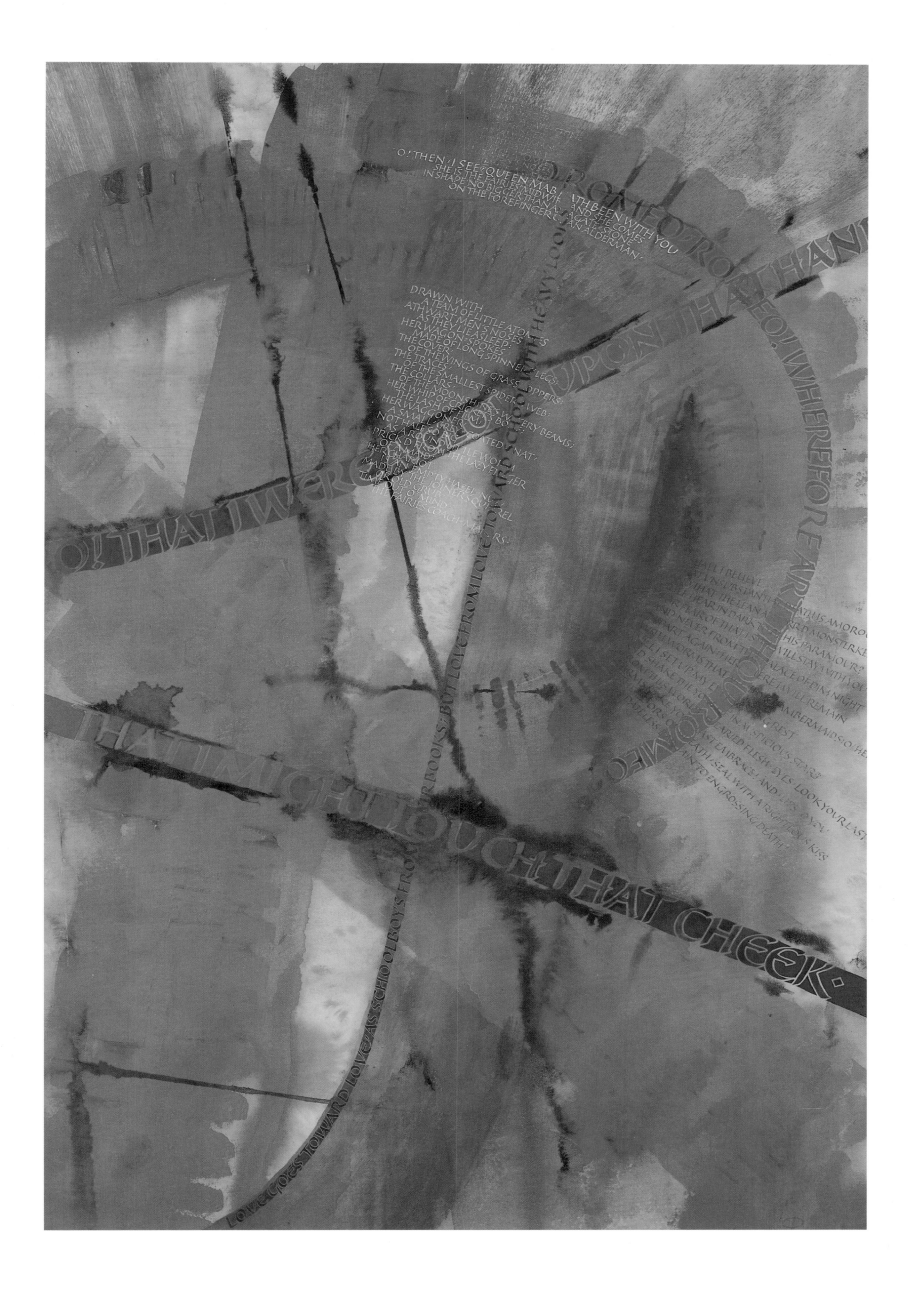

O! ROMEO, ROMEO! WHEREFORE ART THOU ROMEO?

O, THEN, I SEE QUEEN MAB HATH BEEN WITH YOU.
SHE IS THE FAIRIES' MIDWIFE, AND SHE COMES
IN SHAPE NO BIGGER THAN AN AGATE-STONE
ON THE FOREFINGER OF AN ALDERMAN,

DRAWN WITH
A TEAM OF LITTLE ATOMIES
ATHWART MEN'S NOSES
AS THEY LIE ASLEEP:
HER WAGON-SPOKES
MADE OF LONG SPINNERS' LEGS;
THE COVER,
OF THE WINGS OF GRASSHOPPERS;
THE TRACES
OF THE SMALLEST SPIDER'S WEB;
THE COLLARS,
OF THE MOONSHINE'S WATERY BEAMS;
HER WHIP OF CRICKET'S BONE;
HER LASH, OF FILM;
HER WAGONER, A SMALL GREY-COATED GNAT,
NOT HALF SO BIG
AS A ROUND LITTLE WORM
PRICK'D FROM THE LAZY FINGER
HER CHARIOT IS AN EMPTY HAZEL-NUT
MADE BY THE JOINER SQUIRREL
OR OLD GRUB,
THE FAIRIES' COACHMAKERS.

O! THAT I WERE A GLOVE UPON THAT HAND THAT I MIGHT TOUCH THAT CHEEK.

LOVE GOES TOWARD LOVE, AS SCHOOLBOYS FROM THEIR BOOKS; BUT LOVE FROM LOVE, TOWARD SCHOOL WITH HEAVY LOOKS.

PLATE 39

Let Yourself Free, number 2

The text comprises a number of extracts from the writings of the American artist Robert Henri, and makes pleas for self-development and the importance of the freedom of choice in art and life. The scribe-artist Thomas Ingmire responded to the text by using little abstract pictures of letters. United States, 1984 (reduced from 432 × 330 mm).

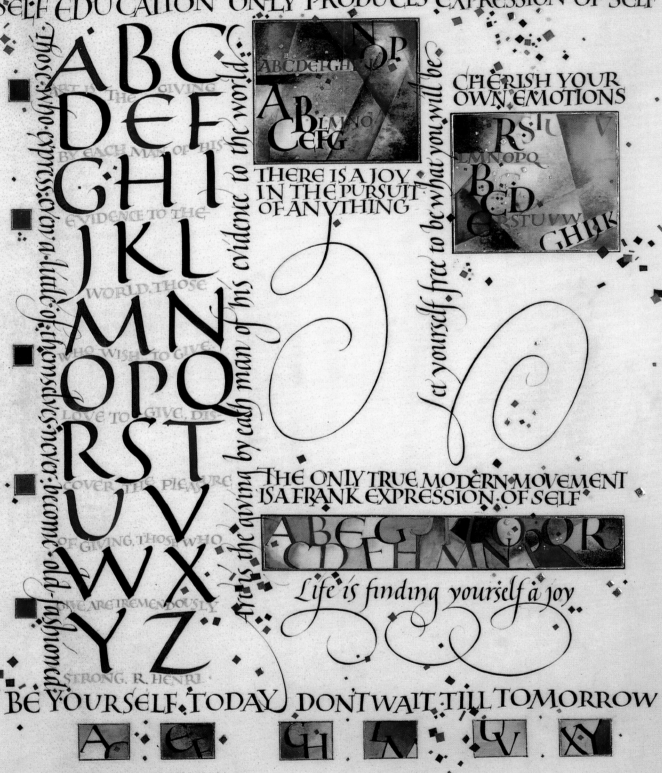

LET YOURSELF FREE
TO BE WHAT YOU WILL BE

There is a joy in the pursuit of anything. Let yourself free a joy; a joy, joy

SELF EDUCATION ONLY PRODUCES EXPRESSION OF SELF

A B C
D E F
G H I
J K L
M N
O P Q
R S T
U V
W X
Y Z

CHERISH YOUR
OWN EMOTIONS

THERE IS A JOY
IN THE PURSUIT
OF ANYTHING

Let yourself free to be what you will be

THE ONLY TRUE MODERN MOVEMENT
IS A FRANK EXPRESSION OF SELF

Life is finding yourself a joy

BE YOURSELF TODAY DONT WAIT TILL TOMORROW

PLATE 40

The Drunken Boat

The artist Thomas Ingmire used words and phrases from a translation of a Rimbaud poem in this piece. The highly charged painted surface and the blurring of verbal and visual elements are to present a purely visual experience of line, movement and colour, to generate and convey emotions. It is a highly sophisticated work and few other living artists have so convincingly used texts to make statements about feelings. United States, 1988 (reduced from 610 × 440 mm).

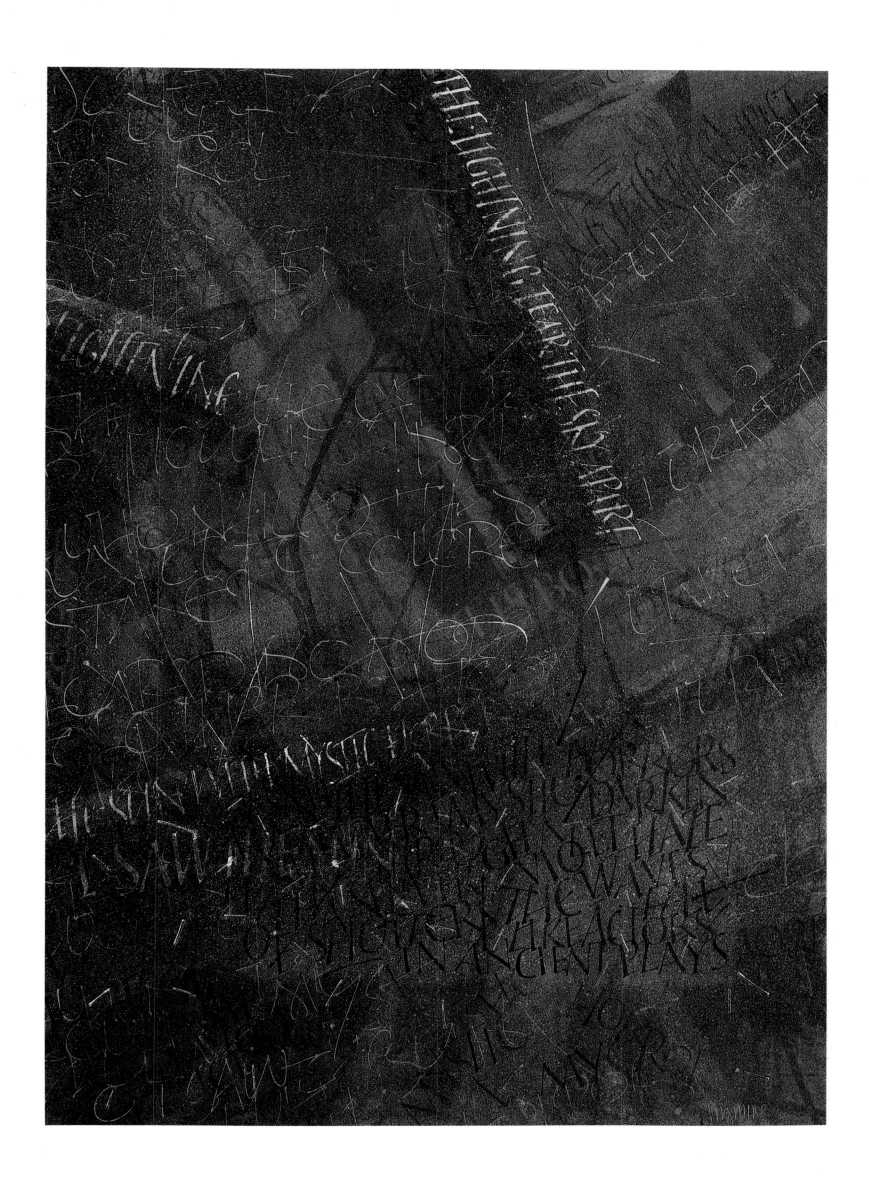